Blake's *Job*

BLAKE'S *JOB*

A Message for our Time

by

Andrew Solomon

Palamabron Press

Published in Great Britain by Palamabron Press
35 Hillway, Highgate, London N6 6AH

Reprinted 1999

British Library Cataloguing in Publication Data
Solomon, Andrew
Blake's Job: Message for Our Time
I. Title II. Blake, William
223.1052

ISBN 0 9522211-1-x

Printed in Great Britain by
Biddles Ltd, Guildford and King's Lynn

CONTENTS

Abbreviations

PREFACE

This is not a scholarly "Urizenic" study or a distillation of previous commentaries on Blake's 'Job'. Rather it is the fruit of a sustained attempt to *use* this great final statement of Blake's message, a message which is more than ever relevant to our needs in the modern world, for the purpose for which he clearly intended it.

Though I am indebted to many writers on Blake, particularly to George Wingfield Digby, who first aroused my interest in his works, to S. Foster Damon, whose commentary on Blake's 'Job' of 1966 and 'A Blake Dictionary' provided many helpful clues to the symbolism, and to Kathleen Raine, who has done so much to clarify Blake's meaning by relating his thinking to the esoteric tradition, I also owe much in a more general way to C.G.Jung and to those who introduced me to Buddhist and Hindu philosophies; and indeed it would be quite impossible to list all the many sources from which over the years I have absorbed ideas which have helped me to understand something of Blake's works.

We have the advantage to-day of knowing of the existence of that large part of the mind which Freud and Jung called the "unconscious"; and Blake, through his language of symbolic imagery, can help us in a truly remarkable way to see what it contains and how this affects our lives. The 'Job' engravings contain his last and clearest statement of what is in effect the central theme in all his work, man's "fall into Division and his Resurrection to Unity". Not only do they present a valuable guide to the path which leads towards wholeness and spiritual enlightenment, which should surely be the goal of all who seek a fully satisfying way of life, but there is also implicit in them a whole, self-consistent, psychological and spiritual system, a unifying pattern which underlies all the various conflicting elements within us which are recognised both by moralists and by analytical psychologists.

Blake's "Zoa" of the Imagination, Los, says "I must Create a System or be enslav'd by another Man's." So anyone who is seriously trying to learn from Blake (or from anyone else for that matter) must interpret his work in the light of his own total understanding, and must be ready to modify that understanding, but not so as to lose touch with his own vision. This is the way in which I have approached Blake's 'Job'.

vii

PREFACE

Kathleen Raine, Désirée Hirst, and more recently E.P.Thompson, have done much to reveal the sources of Blake's ideas. Some come from English dissenting religious sects and others from a broader esoteric tradition. This undoubtedly helps us to understand him better; but whatever he learnt, from whatever source, he assimilated into a vision which was emphatically his own, seen with the power of his own "Poetic Genius" or "Imagination", his own inner link with the universal. And likewise, if we, who live in a different age, are to use his work for the purpose for which he expressly intended it, we must digest its meaning so that it can become part of our own vision - that is to say, we must use it as a series of signposts pointing the way for us to see imaginatively for ourselves in our own terms. In that way its value is ever renewed.

INTRODUCTION

As a work of art, William Blake's famous set of engravings illustrating the Book of Job is undoubtedly one of his finest achievements. But he made it very clear that his art was never an end in itself. Its purpose was to communicate his visionary perceptions for the benefit of mankind. He wrote:

I rest not from my great task!
To open the Eternal Worlds, to open the immortal Eyes
Of man inwards into the Worlds of Thought, into Eternity
Ever expanding in the Bosom of God, the Human Imagination. J. 1. 5.

In this he met with little success in his own time; but the power of his vision lives on in his works, while our need for it remains undiminished.

The outward conditions of to-day's world are certainly very different from those of Blake's time; but human nature, particularly in its deeper aspects, is still essentially the same. Though the external influences on the personality have changed with the changing social and moral climate, the inner structure which responds to these influences has not; nor have the fundamental realities of life, the great truths towards which it is Blake's purpose to point the way. On both of these levels he has much to offer us. Indeed with the decay of trust in old values and beliefs we are in general more conscious of the need for a new way of making sense of life, and more than ever ripe to receive the very positive message that he has to give us.

Blake's ideas, although they belong to ancient and still living tradition, are of an esoteric kind involving concepts largely outside the field of conventional western thought either of his day or of our own; so there existed neither a basis of common understanding, nor even adequate words, through which he could convey them to the world at large. Indeed many thought him mad. He had to invent many terms of his own, and often used these to make very condensed statements whose sense must be totally obscure to the uninitiated. Above all he used the oblique language of symbolic imagery, making full use of its evocative power by combining poetry with visual art.

Fortunately modern developments in psychology, together with a wider dissemination of inward-looking eastern thought, have made it easier for us than for earlier generations to understand him; and though Blake draws much of his imagery and language from the Bible, those of us who are not literal

1

believers in the scriptures should not be put off on that account. Its value as symbolic metaphor does not depend on belief, and we are free to interpret it in terms compatible with our own thinking.

In Blake's illustrations, as in the Book of Job itself, God appears in person and plays an active part. But Blake's image of God is in the exact likeness of Job himself, obviously not a universal deity; while for a *symbol* of divinity he uses the sun, which elsewhere he calls "the Divine Vision". To him there was no other God than the Human Imagination, the Divine Humanity, the creative power in man. His knowledge of the realities of the spirit was a matter of perception, not of belief; and it seems to me that these images of divinity can best be interpreted in terms of our own direct experience, experience of a kind which is central to our motivation, which pervades our lives at all times and is not to be separated off into a compartment labelled "Religion". I shall try to make clear what I mean by this in the course of this discussion. Meanwhile it should be borne in mind that references here to God or to the divine are not intended to be taken literally in terms of conventional religious belief.

Altogether, to understand what Blake has to say it requires, not blind belief in anything, but a clear recognition and evaluation of the direct personal experience which is the fabric of our lives, a fresh look at what we usually take for granted. We may therefore find his art disturbing. It is intended to be. It confronts us with that in ourselves which we have suppressed, with our evasions and self-deceptions. Therein lies its healing power. If it is to do its work we must not take refuge in academic detachment or psychological jargon, but must allow both Blake's images and the poetry of the Book to speak to us, to lead us to the imaginative experience of our own hidden desires, fears, love, hate, pride, guilt, scorn and shame. The important thing is to relate the elements of the story to our own, very personal, feelings so as to throw light on them, and to be ready to sacrifice cherished illusions about ourselves and the world, to free ourselves from the unconscious bondage of false values and open the way for the truth to come to us. This requires courage; but the demand for it comes from our deepest sense of integrity. Blake described this work as "giving a body to Falsehood that it may be cast off for ever". *

He divided life into four stages (though he is rather confusingly inconsistent as regards the names which he gives them), beginning with *Innocence,* followed

* J.1.12.13

2

by the *Fall* into *Eternal Death*, or *Ulro*, a hopeless, sterile, unprogressive state of "death" to eternal realities and of inner conflict, beyond which some people never progress. For others this is followed by a long period of *Regeneration*, of learning from *Experience*, symbolised by years of wandering through the wilderness or forest, during which the regenerating power of imaginative vision gradually penetrates this *Forest of Error* to reveal more and more clearly the truth or reality which has been concealed behind it. For the very few, this process eventually leads to full enlightenment, *Eternal Life*, or redemption. This again does not mean that as individuals they will live for ever, but that in the changing temporal world they will live in the light of timeless realities, whole and free of inner conflict.

The first chapter of Blake's long poem 'Jerusalem' opens:

Of the Sleep of Ulro! and of the passage through
Eternal Death! and of the awakening to Eternal life.

This theme calls me in sleep night after night, & ev'ry morn
Awakes me at sun-rise . . . J. 1. 4.

The Job illustrations are among the more accessible of his many expositions of this theme. Its verbal texts are all from the Bible, while the images themselves are also mostly derived from the Book of Job, or other books of the Bible, so it will not be necessary here to go in any detail into the complexities of Blake's own myth. At the same time the story of Job gives a structural cohesion and clarity to the series which it is not so easy to find in the long illuminated poems, culminating in 'Jerusalem', which contain the most fully elaborated versions of that personal myth.

Blake's vision is nevertheless a self-consistent organic whole, and his symbolic imagery is a kind of shorthand language in which the whole is implicit in each of its parts; but to see this clearly it is often necessary to fill in what he has not so clearly spelled out, to follow the implications of his symbolism some way beyond the direct clues which he provides. The acid test for such an interpretation must be whether it makes convincing sense in itself as a whole.

Though Blake was far from being a conventional Christian, the Bible was a central influence in his life, and of its books Job was one which held a special interest for him. Its magnificent poetry finds many echoes in his works. He had made a few drawings and prints illustrating scenes from it quite early

3

in his life. Later, it may have been around 1805, though opinions differ, he made the set of watercolour drawings for Thomas Butts from which his friend the painter John Linnell commissioned him to make the famous set of engravings. These are dated 1825, when Blake was sixty-eight, but were not actually published until the following year. They consist of twenty-one highly finished designs with a title page. Each design is beautifully framed with marginal designs more lightly executed in which are inscribed the biblical quotations.

Blake follows the story of Job fairly closely to begin with, but as it develops he uses details of its imagery in a very selective way as pretexts for introducing ideas which are certainly not explicit in the Book, treating it rather as a peg on which to hang his own thoughts. The Book of Job poses an enormous unanswered question, to which Blake presents his answer in a work of his full maturity which is as truly inspired with his own vision as anything he produced. A very brief reminder of the story of Job may be useful at this point, though it is hardly a satisfactory substitute for an acquaintance with the Book itself:

Job is a perfect and an upright man, one that "feareth God and escheweth evil"; and his virtues seem to be rewarded with great prosperity. God points him out to Satan, who cynically suggests that it is easy for Job to be faithful to God when God has treated him so well and he has so much to lose. So God twice grants Satan permission to test him. On his first visit, Satan assails Job with outward violence. Through the agency of marauding tribesmen, the "fire of God" and a great wind, he deprives him by force of his flocks, his servants and even of his children. The second time he comes, Satan attacks him more insidiously from within, afflicting him with boils, symbolising the compulsive corruption of his bodily desires and the debasement of love. But Job still remains faithful.

His friends now come along, lamenting his misfortunes; but they argue that, since God is just, these afflictions must be in punishment for sins which he has committed. This argument occupies by far the greater part of the Book. Job, the perfectly conditioned man, denies that he has sinned; he repeatedly asserts that he has done nothing to deserve God's punishment. But by this assertion he seems to imply that he can understand God's ways, as if God himself were conditioned by rational laws.

So God finally speaks to him out of the whirlwind (or maybe, more literally, the whirlwind, as an example of elemental violence which threatens the good and the wicked alike, prompts Job's own thoughts): God speaks of the wonders of his Creation, the terrible forces of Nature, its beauties and its mysteries, the strange ways of all its many different creatures, each with marvellous and special abilities.

INTRODUCTION

He describes the two mighty monsters which he created, Behemoth and Leviathan, beside which a man's strength is as nothing. Where was Job when all these things were made? Can *he* understand or control them? Who is he to say that God should not cause him to suffer? Is he trying to tell God what is right?

Job now repents of his presumptuousness but his friends still cling to the delusion that the justice of God can be understood by man. In the end God forgives Job when he prays for them; and all is restored to him.

The first ten plates of the series illustrate Job's original prosperity, his downfall and his interminable fruitless arguments with his three friends. These arguments, with their lack of real insight, show all the unprogressive character of *Eternal Death*. Though these plates are by no means without interest, it is in the second half of the series that Blake makes his most important contribution. It is not until the twelfth plate that the regenerative process really begins (though it is foreshadowed in Plate 11). The last four plates deal with Job's restoration to prosperity, which Blake treats as his attainment of enlightenment.

The Plates

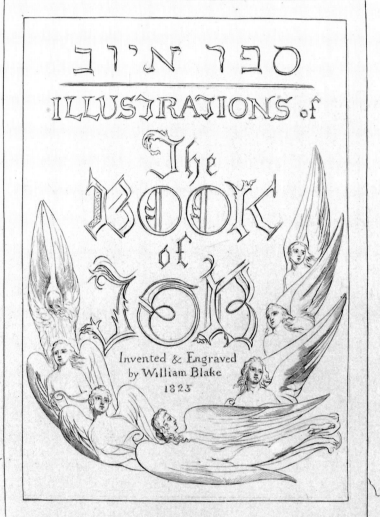

ספר איוב

ILLUSTRATIONS of

The BOOK of JOB

Invented & Engraved
by William Blake
1825

London Published as the Act directs March. 8: 1825. by William Blake N° 3 Fountain Court. Strand

1.
TITLE PAGE

In its symbolic imagery the Title Page sums up the purpose and subject matter of the whole series.

Around the title, which is written both in Hebrew and in Gothic characters, seven angels form a path which falls and rises again, yet always leads in one direction, like the path of man through life, here exemplified in the life of Job. The convention is observed according to which in pictures of the Last Judgment the side of the Fall is that of the left hand of God, which is actually the right side of the picture as we look at it, while the redeemed rise up on our left.

These seven angels are the seven traditional creator-beings, forms in which the divine power is manifest, which Blake sometimes calls the Seven Eyes of God or the Seven Lamps of the Almighty. He names these Lucifer, Molech, Elohim, Shaddai, Pachad, Jehovah and Jesus, God-names which seem to be associated with seven stages of spiritual development from the Fall to Redemption. These "lamps" or "eyes" must have their origin in the seven planets known to the ancient world which moved and changed against the background of the fixed stars of the Zodiac and were thus associated with change, with creation and redemption; and no doubt this has given the number seven its special significance. In the Book of Revelation seven angels are instrumental in the destruction of the false, preparing the way for the coming of the New Jerusalem. This symbolises the purpose, on the level of the individual life, behind the Job engravings as behind virtually all of Blake's work.

It is through imaginative effort, through the intuitive power of the creative imagination, Blake's "Poetic Genius", not by mere reasoning, that we can find out and correct the errors in our attribution of spiritual value and authority, errors which divide and misdirect our will; and Blake sees Art, and not least his own art, as a vehicle for the redeeming truth.

Some of the angels of the title page can be seen to carry scrolls and quill pens, which suggests that they are manifestations of this Poetic Genius. Indeed the work of redemption is itself creative work, a kind of art. Throughout the series books and scrolls are much in evidence. S. Foster Damon links books with the Law and scrolls with Inspiration. Scrolls, being hand-written, suggest direct insight, first-hand inward knowledge, the poetic products of the creative imagination, personified in Blake's own myth as Los; whereas books may be mechanically reproduced, and transmit prosaic rational ideas, laws and factual information, which can be mechanically communicated in words. These are the products of reason, Blake's Urizen. The moral law laid down in a book has behind it a purely external authority.

The single direction of man's progress through life may be seen, in relation to the feminine, containing, principle, as that of progressive separation. Starting with physical birth, this continues through a series of symbolic births, moving always out of a state of containment and dependence and into one of greater freedom, but also of more personal responsibility and exposure to suffering. This movement away from Mother is itself an expression of the masculine spirit of independence and active self-assertion. But though our true need is to follow this masculine spirit and to accept the reality of our separateness and exposure to the painful hazards of life, we are constantly beset with the temptation to cling to dependence - to linger in the comfort and safety of a make-believe "womb". There is a tension between these two urges.

In early childhood the inner judgment which comes from the centre of our own being at first tells us to trust entirely in the guidance of our parents. In effect we project its authority onto them, the ultimate authority behind all values, the archetypal principle of divinity. Later, with the assumption of more personal responsibility, it is gradually transferred to a more remote and universal image of moral authority, whether social or consciously religious. Many never progress beyond this, remaining in the "fallen" state of Eternal Death - of moral dependence and inner conflict.

Blake's purpose is to show the way that leads on beyond this to a state in which the outward projection of the principle of divinity has been completely withdrawn, and in which, for each individual independently, moral authority is seen to emanate wholly from the spiritual centre, which is at once the essence of his own being and his link with the universal (thus in the first picture of the series prayers are read from two books of received wisdom; but in the last, one scroll of direct vision is at the very centre). It will become apparent that the more fully he is identified with this inner reality, the more clearly he will see and value the same reality which is at the centre of all other beings, so that love becomes the mainspring of his will. Through love he comes back again to the Other in a new creative union.

Our Father which art in Heaven hallowed be thy Name

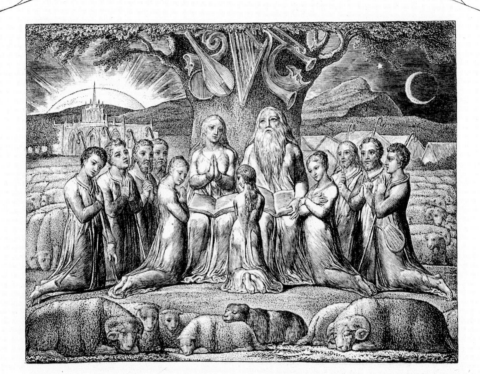

Thus did Job continually

There was a Man in the
Land of Uz whose Name
was Job. & that Man
was perfect & upright

The Letter Killeth
The Spirit giveth Life

It is Spiritually Discerned

& one that feared God
& eschewed Evil. & there
was born unto him Seven
Sons & Three Daughters

WBlake inv & sculp

London. Published as the Act directs. March 8: 1828. by Will. Blake N 3 Fountain Court Strand

Proof

2.

DOWNFALL
Plates 1 to 10

The first ten plates deal with Job's downfall. Though they contain many hints of the underlying causes of his suffering, at this stage, since he himself is unaware of those causes, there is nothing he can do about it. These plates are chiefly concerned with the *effects* of Job's error, and they may help us to recognise the relevance of the whole story to our own experience. Blake points to patterns of compulsive behaviour - by which I mean behaviour into which we seem to be inwardly compelled, either consciously or unconsciously, in spite of our better intentions, and in which, like Job, we are all to some extent caught - and to the suffering which this brings. Later he will reveal their deeper sources in ourselves.

So many of us are unaware that life could hold anything different. We tend to believe, like Job at the beginning of the story, that the conventionally ideal state of virtuous prosperity is the norm, and that we personally are unaccountably and unjustly deprived of our full enjoyment of it. Pride forces us to keep up outward appearances like everyone else and to cling to the idea that our troubles all stem from outside ourselves; and we resist the insulting suggestion that there could be any need to understand ourselves better.

PLATE 1
Thus did Job continually

And it was so, when the days of their feastings were gone about, that Job sent and sanctified them, and rose up early in the morning, and offered burnt offerings according to the number of them all: for Job said, It may be that my sons have sinned, and cursed God in their hearts. Thus did Job continually.

Job and his family are assembled under the massive Oak Tree which, though in the end it will appear in quite a different light as the Tree of Life, here, like most of Blake's trees, is in effect the Tree of the Knowledge of Good and Evil. This is an external source of moral judgment whose values can be applied by the reason. It separates the opposites, day from night, sun from moon. The oak in particular is Blake's symbol for the "Druid" religion, which was really his name, with overtones of human sacrifice, for the debased conventional Christianity of his day, which he saw as a cruel religion of punishment for sin. Surrounded by the signs of their material prosperity, they are saying their prayers, in conventional attitudes of pious meekness, to "Our Father which art in Heaven", an external, all-powerful, father-god whom they need to have on their side, and who needs to be propitiated in case they may have sinned.

This child-like, unquestioning, obedience to authority looks like a kind of innocence; but, in trying thus vainly to cling to the dependent innocence of childhood, Job fails to recognise and to shoulder the responsibility which is truly his as an adult. The tent-like shape in the margin may symbolise the maternal, sheltering, aspect of this rather insubstantial system of order, the Tabernacle containing the Ark of the Covenant as the prototype of Mother Church.

PLATE 1

Job and his wife have large books open on their laps: for their prayers and for their moral guidance they depend, not on their own vision, but on the writings of other men which traditionally embody the Law of God. The two books, like the two tablets of the Law in the Ark of the Covenant, no doubt symbolise the dualistic nature of this Law of good and evil. A Gothic church stands ambiguously between them and the sun, the symbol for what Blake calls the "Divine Vision", the true spiritual source. Related ideas are suggested by the inscriptions on the altar below and by the musical instruments hanging on the tree unused. The meaning of this will become clear in the final plate: here they are singing no spontaneous, creative, song of praise. The seven sons with their seven crooks preserve, like bishops, the order according to the Law, preventing their flock from straying. The docile animals in the foreground are (spiritually) asleep - in the "Sleep of Ulro".

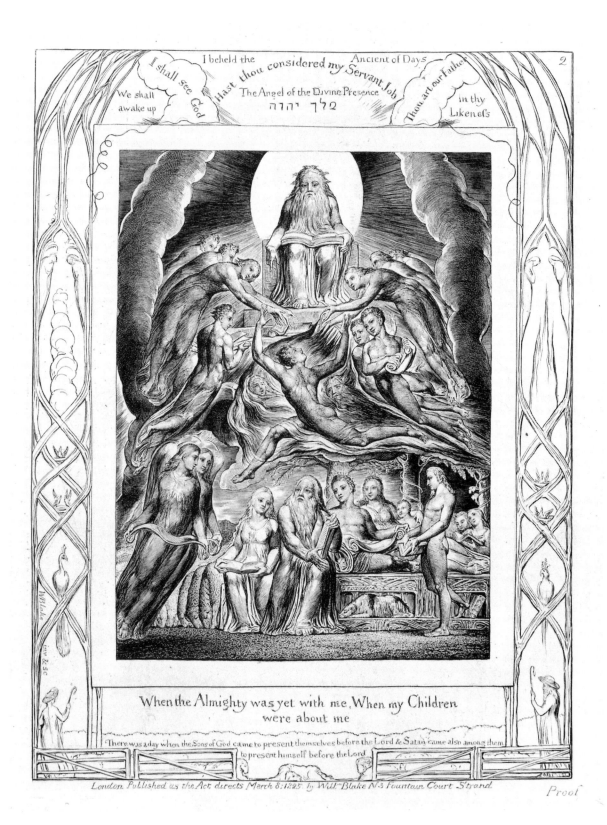

I shall see God
We shall awake up
I beheld the
Hast thou considered my Servant Job
The Angel of the Divine Presence
מלך יהוה
Ancient of Days
Thou art our Father
in thy Likeness

When the Almighty was yet with me, When my Children
were about me

There was a day when the Sons of God came to present themselves before the Lord & Satan came also among them
to present himself before the Lord

W Blake inv & sc

London. Published as the Act directs March 8: 1825. by Willᵐ Blake Nº 3 Fountain Court Strand.

Proof

PLATE 2

When the Almighty was yet with me,
When my Children were about me

Although this design could be seen as a literal illustration of the text with unexplained additions, I shall keep throughout to a psychological rather than a theological interpretation. The upper part of the picture, which represents heaven and is separated from the earthly scene by a thin veil of cloud, is taken as an image in Job's mind rather than as an external reality. The cloudy veil is symbolically equivalent to the veil ordained in the twenty-sixth chapter of Exodus to conceal the holy of holies within the Tabernacle from the eyes of the uninitiated so that they could project the value of sanctity onto what lay behind it.

There is a marked change in Job's bearing. With evident pride he holds up the Book of the Law to the two angel witnesses to his goodness and perfection. He imagines God asking Satan: "Hast thou considered my Servant Job, that there is none like him in the earth, a perfect and an upright man, one that feareth God and escheweth evil?" Satan is at once the Tempter, who leads him into this self-conscious pride, and the Accuser, who, through that pride, will be able to attack him with accusations of sin. This latter destructive component of the personality is called by Blake the "Spectre".

Job's whole family is living a life of ease. Whereas before they were kneeling in humble devotion and wearing uniform monastic garb, now some of his sons are shown naked, freely expressing their independent, individual, views, whether these are symbolised by books of rational knowledge or by scrolls of imaginative insight. Close behind Job, one of his sons has a scroll, like his counterpart in heaven, and a kind of sparkling halo or wreath round his head - is he the Poetic Genius, the potential Redeemer?

There is also a suggestion of a similar halo on the top of the head of the daughter just behind him. She may be destined to serve in the final plate as the symbol of the redeemed man's "other half", the object of his love, personified by Blake as Jerusalem, at once a woman and a city. Opposite the two angels with their scrolls another son stands conspicuously in the foreground on the side of the Fall (and on his left leg, a sign of Error). He holds a book - is he perhaps the rational materialist?

Reflecting this diversity of views, instead of one tree, there are now three, each with a serpent-like vine spiralling up it as the Serpent traditionally spirals up the Tree of Knowledge. There are in fact three fundamental and mutually conflicting scales of value which confront a man who tries to be good according to a set of fixed rules. According to one, good is order, evil, chaos; according to another, good is pleasure and evil is pain; while for the third, good is power and evil is weakness. The vines, associated through the wine of the Eucharist with blood and suffering, give a hint of conflict to come.

In the flames on each side of Satan appear the shadowy heads of Job and his wife as the male and female aspects of Error. The meaning of this three-fold nature of Error, which is related to those three sets of values, will become clear in Plate 15 and also in Plate 16, where, fully materialised, all three of these figures are cast out of heaven.

Above, God, in the exact likeness of Job, sits on his Judgment seat with the Book open on his lap. His ten sons surround the throne (ten is the number of the heavenly spheres and of the *sephiroth* of the Cabbalah), and in the centre, Satan (Lucifer, of the sphere of Venus, the Morning Star), who is one of them,

PLATE 2

is replying to God, who seems to have challenged him to find Job wanting. He says: "Doth Job fear God for nought? Hast not thou made an hedge about him and about his house, and about all that he hath on every side?" He expresses Job's secret doubt: is he really good in his heart? Or is it only because things have gone well for him and he has so much to lose that he complacently praises the Lord, and is careful to obey the Law which he believes to be the condition of his prosperity? In the bottom margin the sheep are watched over by a shepherd and shepherdess who look very much like Job and his wife. The flock is indeed very well fenced in and the only opening is guarded by a dog. There is little chance of the sheep going astray or being attacked.

There is much interesting detail in the margins. Though, for Blake, Gothic stands normally for the True Religion, in Plate 1, the rôle of the Gothic church was ambiguous - did it transmit the sun's light or did it obscure it? Here, on each side, the Gothic motif appears in an even more dubious light. Web-like Gothic tracery is formed out of stylised trees, combining two of Blake's related symbols, the Tree of Mystery and the Web of Religion. The latter is a degraded form of the veil, mentioned above, which was placed before the Ark of the Covenant containing the tablets of the Law, to set apart a place for the hidden mystery of the most holy. But Mystery is the name of the Great Whore of Revelation,* a device for conjuring up an illusion of the divine comparable with the illusion of love conjured up in the embrace of a whore. The Tree of Mystery, an aspect of the Tree of the Knowledge of Good and Evil, proliferates to form the Forest of Error, with which the Web of Religion is more or less synonymous. This forest is the Wilderness through which we all have to wander in our search for the Promised Land, the redemption for which we long.

* Revelation 17. 5

On this journey we are led by the pillar of cloud (rational morality) by day (consciously) and the pillar of fire (energy or desire) by night (unconsciously), two conflicting sources of guidance. But both are manifestations of the Angel of the Divine Presence,* whom Blake elsewhere associated with the false "Druid" religion of punishment for sin. These two symbols of the opposites sundered by rational belief and morality are to be seen within the tree-web which is disguised as the Gothic tracery of True Vision. There also perch in this tracery the peacock of vanity and the parrot of empty repetition, errors into which, in these first two plates, Blake shows Job to be falling through religious observance itself. The shepherd and shepherdess who guard Job's material assets likewise stand, with the probity of the honest man of business, within this framework of religious morality.

The ambivalence of all these symbols suggests that it is necessary to experience sin and error as part of the true path. Indeed an important part of Job's error is that his whole aim is to avoid that experience. But this is impossible. Good and evil simply cannot be separated in that way. There can be no such certainty or purity in life. But he has yet to learn this. There is perhaps further ambiguity in the texts in the top margin. They contain truths later to be revealed, but it is doubtful whether Job has yet understood them in their true sense.

Above the pillars of cloud and fire, two pairs of angels emerge from the Gothic tracery, watching tenderly over the Children of Israel in their trials and tribulations and backslidings on the long and painful journey of Experience, the journey on which Job is about to embark.

* This is a dualistic conception of the divinity identical with the Angel of God (elsewhere called by Blake the "father of Good and Evil, Adam and Satan"). See Exodus 14. 19, VLJ 80-81, the Laocoön Plate and EG vi. 29

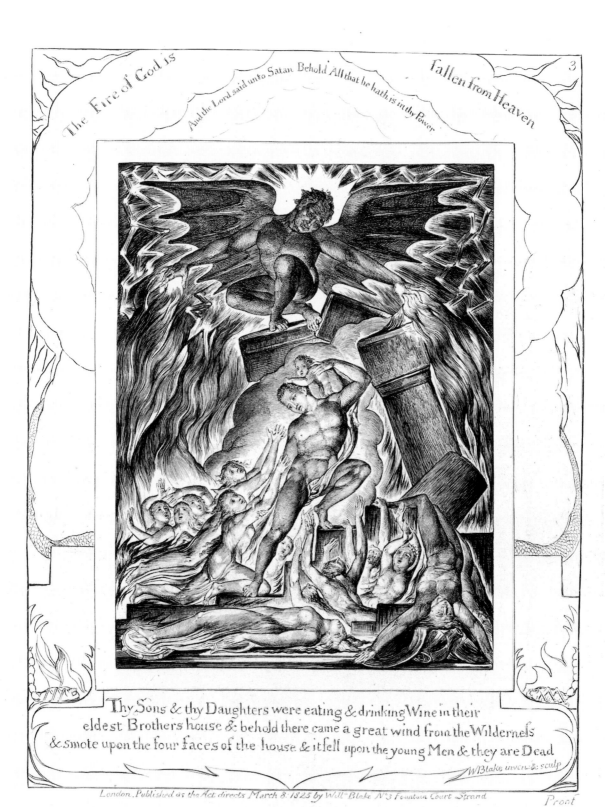

The Fire of God is **fallen from Heaven**

3

And the Lord said unto Satan Behold All that he hath is in thy Power

Thy Sons & thy Daughters were eating & drinking Wine in their
eldest Brothers house & behold there came a great wind from the Wildernefs
& smote upon the four faces of the house & it fell upon the young Men & they are Dead

WBlake invenit & sculp

London, Published as the Act directs March 8: 1825 by Will⁹ Blake N° 3 Fountain Court Strand

Proof

PLATE 3

Thy Sons & thy Daughters were eating & drinking Wine in
their eldest Brothers house & behold there came a great wind
from the Wilderness & smote upon the four faces of the
house & it fell upon the young Men & they are Dead

Satan begins his work. In this design Blake has added much that is not in the text. I think there is little doubt that it is his view of the inner meaning of the story that the "spectre", or Satan as the Accuser within, has taken possession of Job, tempting him into the inflated conviction that he can wield the wrath of God, attributing divine authority to his own frustrated will.

Outraged by his children's lack of respect for the moral law as he sees it and afraid of their independence of mind, he is possessed by an uncontrolled fury of righteous indignation (the wind from the Wilderness), and, with jagged lightnings of hatred, in the name of God rejects them utterly for their sinfulness. And the sadistic Satan hidden within him, who is masquerading as God, is obviously enjoying this indulgence of dominating power.

If a man feels that his security depends on his being able to justify himself according to a set of rules, he is bound to fear those who reject those rules. They seem to threaten the whole fabric of the social order on which he depends. But his hands are tied by rules where theirs are free. All he can do is to resort to righteous indignation; but when this has no effect, because he is invoking an authority which they do not recognise, he becomes all the more furious. If he cannot accommodate them in his world, he may eventually feel driven to escape from the problem by rejecting them utterly and refusing to have anything to do with them.

Although it is not stated in the text that the seven sons and three daughters which Job has at the end of the story are the same ones that he had at the beginning, Blake makes some of them recognisably the same in Plates 2 and 21. This seems to imply that his children are not literally dead, but only dead to him. Indeed in this design they are mostly shown as still alive. They are not all equally affected by their father's anger. Some are prone to self-accusation, the enemy within which joins forces with the outward accuser. These flounder in attitudes of distress or despair. One of the daughters lies at the front with a lyre under her hand, and her feet, symbolising her lower instincts, on a tambourine which suggests the erotic dance. The tender, poetic, muse is slain by the harsh and ruthlessly rational Spectre, condemned for her eroticism. One of the sons is in the position of upside-down crucifixion with a pile of valuable plate beneath him. This symbolises the sacrifice of spiritual for material values. Maybe this is the misguided rational materialist who held a book in the previous picture. He has no spiritual vision to sustain him against the Accuser.

But in reality not all are prostrated by their father's wrath. The central Herculean figure, possibly representing the Poetic Genius, seems far from being crushed, and he holds up the innocent child, who, like himself, is free of self-accusation. These realities are separated from Job's imaginings of power by the cloud barrier which surrounds them.

In the margins the "Fire of God" is seen around the cloud. Lower down on each side is a scorpion, another symbol of the Fall and the threat of death. The scaly serpent which here begins to emerge on each side is an image of Satan in his other rôle as the Tempter, that in which he tempted Eve.

21

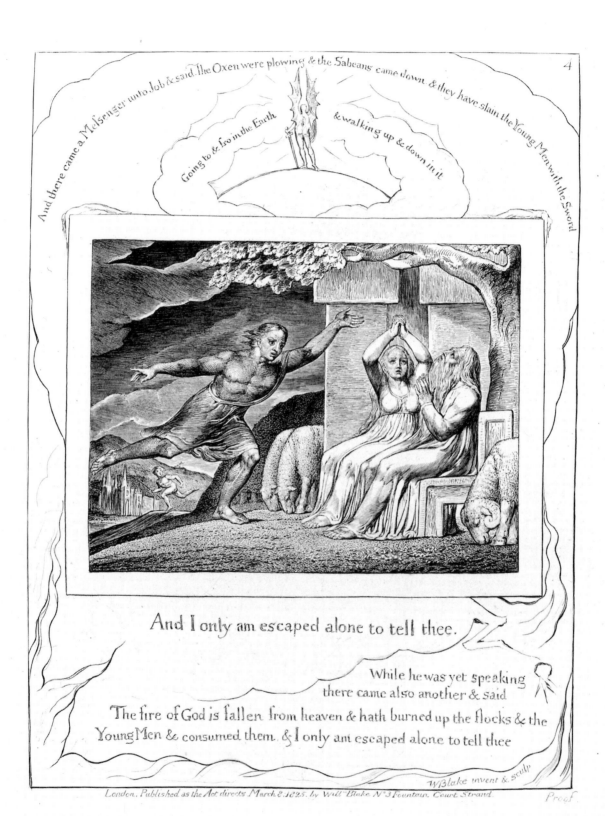

And there came a Messenger unto Job & said. The Oxen were plowing & the Sabeans came down & they have slain the Young Men with the Sword

Going to & fro in the Earth

& walking up & down in it

And I only am escaped alone to tell thee.

While he was yet speaking
there came also another & said

The fire of God is fallen from heaven & hath burned up the flocks & the
Young Men & consumed them, & I only am escaped alone to tell thee

W Blake invent & sculp

London, Published as the Act directs March 8. 1825. by Will Blake N 3 Fountain Court Strand.

Proof.

PLATE 4

And I only am escaped alone to tell thee

After the satanic outburst by which Job had been carried away, one by one the messengers arrive - he becomes aware, bit by bit, of the damage done through his loss of self-control. Blake has altered the order of the messages of disaster: the first thing that must strike Job is that he has cut himself off from his children; the second is that he has behaved in a way that has undermined the reasonable and kindly "image" which he sees as his real self, the basis on which he is accepted by the world; so we may imagine that though consciously he still firmly believes his anger was justified, he feels nevertheless uneasy, inclined to anticipate hostility in others, however undeserved. Satan, above, still seems to rule the world as he stands "on the bare convex of this World's outermost orb"*, a sword in his left hand and a shield in his right.

In his ordinary state of mind, to which he has now returned, Job presents an entirely benign face to the world, innocent of any self-will, impeccably justified in all his wishes and in all that he does, submissive to the will of God as he sees it, and deserving of God's paternal protection. The Gothic church, though rather plainer than before, is still in sight, and sheep graze peacefully around him and his wife as they sit under their tree. He cannot justify action against anyone on his own account, and the only weapon which he can allow himself to use in his defence is righteous indignation, the invocation of his father-god's authority; but this was only partially effective even against his own unruly children. It is quite useless against those like the marauding Sabeans and Chaldeans - aggressive heathen foreigners - who do not recognise his God or his moral code. He is at their mercy. He sees in their violence the devilish malice by which he himself had been unconsciously possessed in Plate 3.

Such unacknowledged impulses, dissociated from the conscious will, can manifest themselves either by taking possession of us in this way or through the mechanism of *projection,* whereby they are seen as outside ourselves, usually attributed, as here, to other people. Jung defined projection as "displacing a subjective process out into an object". This projection of the Spectre, the devil within oneself, greatly magnifies the apparent power of those who seem hostile towards us. Not only do they appear to us larger than life, but also we may attribute to them a devilish malevolence against which we feel helpless.

Thirdly, Job is assailed by the "fire of God", which Blake shows as a flash of lightning and an exploding thunderbolt in the lower margin. This is a foretaste of the revelation that is to come of a different side of "God", who also created Behemoth and Leviathan, God as power. It is Job's child-like dependence on his illusory, just, father-god which leaves him unprepared for such an "act of God", the random, accidental, violence and conflict of Nature. At some level he is ashamed of his failure to face and accept this like a man, realistically and uncomplainingly, and this is another "loss", a blow to his self-esteem, even if he does not consciously recognise it.

This first visit of Satan can be summarised as error in the field of power and authority. In Plate 3 Job believes he can wield divine power and authority, while in Plate 4 he is its helpless victim. In his state of moral dependence, outside the impersonal framework of received rules he has no mode of relationship in between complete domination and complete submission.

* Milton 'Paradise Lost' Bk III

23

PLATE 4

On the upper corners of the main design, two small figures, suggesting feminine tenderness, are prostrated in grief. Such figures, expressing the general mood of the scene, appear in the same place in many of the engravings.

Behind Job and his wife is a curious piece of vaguely classical architecture. In contrast with the unqualified vertical, or spiritual, emphasis of the Gothic church, the vertical (spiritual) elements at home are heavily capped with massive horizontal (material) stones. The dualism seems to be stated again in the duplication of this motif. There is a further curious vertical and horizontal emphasis on their seat. Intentionally or not, Job and his wife are supported by a false perspective.

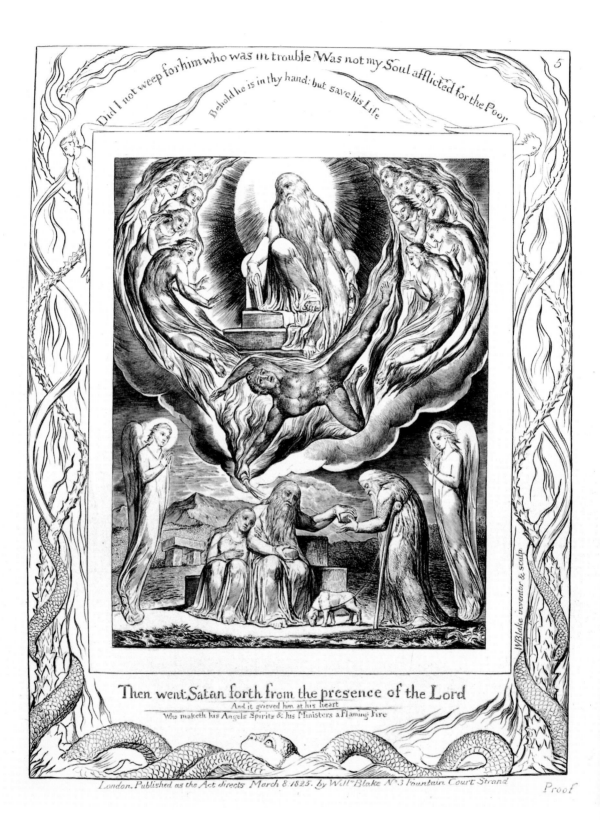

Did I not weep for him who was in trouble Was not my Soul afflicted for the Poor

Behold he is in thy hand: but save his Life

5

Then went Satan forth from the presence of the Lord

And it grieved him at his heart

Who maketh his Angels Spirits & his Ministers a Flaming Fire

WBlake inventor & sculp

London. Published as the Act directs March 8 1825. by Will^m Blake N° 3 Fountain Court Strand

Proof

PLATE 5

Then went Satan forth from the presence of the Lord

On his second descent, Satan tempts Job in the opposite direction - one could see it as Job's natural reaction after the angry excesses of Plate 3 and his realising in Plate 4 how much damage these have done. He now tries to compensate with false love for his attempted abuse of power. With self-conscious charity he gives a loaf of bread to a blind beggar; but the quotations at the top of the page show that he does this, not out of any genuine concern for the beggar, but simply to prove how good and kind he is. And it is evident in his expression and bearing how uneasy he feels about it. There seems to be a distinct air of humbug too about the obsequious, fat, old beggar. This false charity is degrading both to giver and to receiver (it is both given and received with the left hand); and as for the two angelic witnesses for whom Job is performing this act, their hair is bristling! Their appearance is markedly less solid and assured than it was in Plate 2.

In his heaven, God's air of self-doubt exactly matches Job's below. The halo is dimmed, the book closed, and, like the scroll in his other hand, disregarded. His left foot is slipping down towards Satan, who looks more vigorous than ever as he dives down in flames to pour his poisons into Job's ear, leading him further into error. The ear, for Blake, is the organ of spiritual perception.

The landscape behind is deserted. In place of the Gothic church there is now a "Druid" dolmen. In the margins, the great serpent which began to emerge in Plate 3 is now fully revealed, its double tail twined with the serpentine bramble and twisting, flame-like, vegetation. These represent the threatening aspect of the life force and the compensating growth of lust behind this false front of virtuous self-denial. As compared with the border of Plate 2, a wild and dangerous force has transformed the orderly, gothicised, appearance of Nature. The little angels at the top are horrified.

There are many points of similarity between this design and Blake's beautiful watercolour drawing entitled 'The Fall of Man' (now in the Victoria and Albert Museum), notably in the figure of God and the position of his feet; while the serpent and bramble motif in the margin here is to be seen there in the Tree of Knowledge with its tempting red fruits. Thorns and thistles are part of the curse described in the Book of Genesis with which Adam was expelled from Paradise.

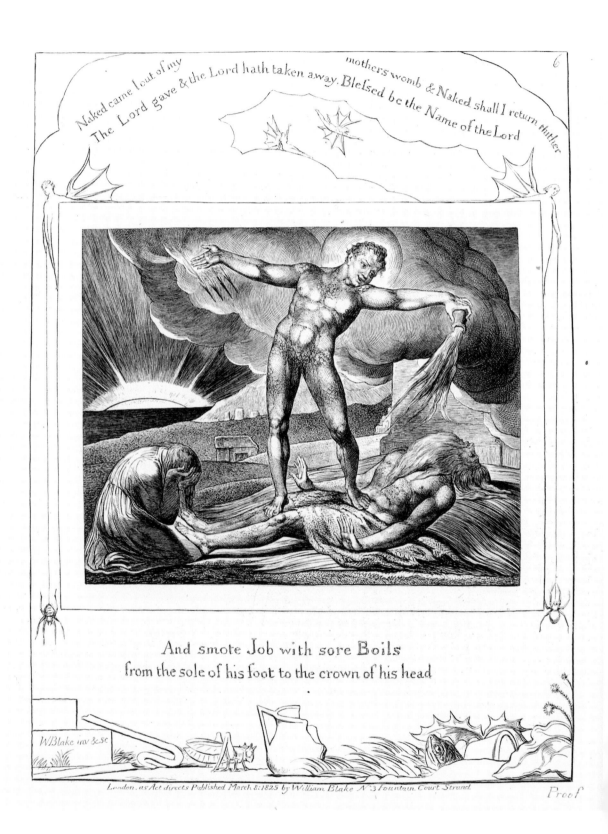

Naked came I out of my mothers womb & Naked shall I return thither
The Lord gave & the Lord hath taken away. Blessed be the Name of the Lord

And smote Job with sore Boils
from the sole of his foot to the crown of his head

W Blake inv & sc

London, as Act directs Published March 8: 1825 by William Blake N 3 Fountain Court Strand

Proof

PLATE 6

And smote Job with sore Boils from the sole of his foot to the crown of his head

Satan has come down through the clouds once more and is again in possession of Job's conscious mind. This time he comes in the dual rôle of Tempter and Accuser to complete Job's downfall.

The great serpent in the margin of Plate 5 was a sign that the self-righteous are prone to temptation. With his left hand, as the Tempter, Satan now joyfully pours the flames of compulsive desire from a vial of poison to corrupt the flesh. With his right hand, as the Accuser, he smilingly calls down from a clouded heaven arrows of wrath against Job for his sinful thoughts.

Satan has again usurped the divine power, though a different aspect of it this time. He even has a cloudy halo. Following tradition, Blake always depicts him without genitals: he is uncreative and effectively impotent, being only a form of self-deception. He has serpent-like scales on the pubic region of his body, which, like the bat's wings which he has in the well-known painted version of this design in the Tate Gallery, are his traditional attributes.

The design as a whole arouses a sense of acute moral discomfort. Everything seems desperately wrong. Job feels naked and vulnerable, stripped of all his clothing of self-esteem, the confident face he has shown to the world. He is prostrated and trampled on by Satan; only his loins (the will) are covered with a coarse cloth of penitence or shame. His wife can only minister to the lowest part of his nature, mere physical lust, represented by his feet.

In the margins, instead of angels, there are spirits with bat's wings, Satan's creatures.

Two of them lower spiders, cruel devourers associated with the Web of Religion, the snare of conventional morality in which Job is caught. And this is represented in the main design in the "Roman" ruins beneath the opaque clouds associated with Satan. Generally *Roman*, like *Druid*, is contrasted with *Gothic* and stands for false religion.

At the bottom, the locust, the web-footed, cold-blooded, frog, the thistle and the sharp spiny rushes, all evoke the curse of Adam and the malevolent and repellent aspects of Nature, while the broken earthenware pitcher not only suggests the potsherd with which Job scraped himself, but also symbolises the broken body, and the broken shepherd's crook, the broken personal authority. In the previous plate self-denial was compensated in the margin by lust, but here conscious lust gives rise to disgust and revulsion.

Satan's second visit is concerned with error in the field of love. In Plate 5 it is the error of hypocrisy, the outward simulation of love to deceive others, being "nice" in order to be liked; in Plate 6 it is that of lust, the inward falsification of love to deceive oneself in sexual fantasy. This double deceit is doubly punished. Inwardly Job feels both guilty - condemned by God - and tainted in his own being; but he is not yet able to understand why. He believes he has done nothing wrong; but he humbly accepts his fate: "The Lord gave & the Lord hath taken away. Blessed be the name of the Lord".

The sun sets beyond the dark sea as Job embarks on his symbolic night journey of self-discovery through darkness and suffering to an eventual spiritual rebirth or sunrise.

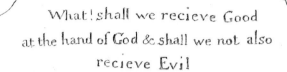

What! shall we recieve Good
at the hand of God & shall we not also
recieve Evil

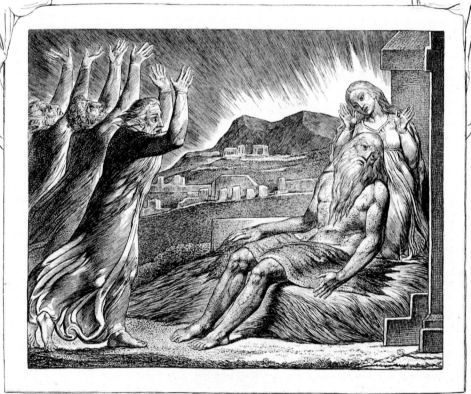

And when they lifted up their eyes afar off & knew him not
they lifted up their voice & wept. & they rent every Man his
mantle & sprinkled dust upon their heads towards heaven

Ye have heard of the Patience of Job and have seen the end of the Lord.

W Blake inven & sculpt

London. Published as the Act directs March 8. 1825 by William Blake N 3 Fountain Court Strand

Proof

3.

"ULRO"

PLATE 7

*And when they lifted up their eyes afar off & knew him not
they lifted up their voice & wept. & they rent every Man his
mantle & sprinkled dust upon their heads towards heaven*

Job's self-confidence and self-esteem have been shattered; but he still has to face the world.

His friends arrive with ostentatious gestures of grief and dismay, but he finds it hard to look them in the face, stripped naked as he is, while they are all fully clothed in their complacent and superficial public attitudes. These they are about to expound at great length.

His wife stands behind him, also expressing dismay, but pity too. She represents his "inwardness", his capacity for inward vision as opposed to that side of him that faces the world. So she is always on the other side of Job from his three friends, who represent that outer world, the society in which he lives. But at the top of the page is Job's answer to her when she tells him to curse God and die: at this stage she only brings despair. Here, therefore, she is on Job's left, the side of the Fall - she has not yet penetrated to the source of the inner light. But in almost all her other appearances she is on his right, the side of redemption: it is through his inward vision that Job will be redeemed.

Behind her rises a sort of cross, which, for Blake, symbolises the false religion of punishment for sin, and in its horizontal and vertical members embodies the unreconciled, conflicting, opposites (it is conspicuously absent from his Gothic churches, but prominent over his representations of the "Roman" dome of St.Peter's). Here its position, form and perspective are curiously unresolved. It is not conceivable that this could be due to sheer incompetence, clumsy though Blake's drawing sometimes is. In earlier versions it is clear that Job and his wife are seated in the angle of a building whose perspective is quite plain. As before in Plate 4, Blake may be making a point about the unreality of abstractions, if in a rather perverse way, by a deliberately rigid, uncompromising, adherence to horizontal and vertical, material and spiritual, black and white, which misrepresents reality.

"Roman" ruins proliferate in the grim landscape and a lurid after-glow comes from behind the dark mountain. In the margin Job and his wife stand dejectedly under bare trees. They still have their shepherds' crooks, and beyond them the landscape is of gentle pastures and trees. Across it is written a passage from James 5.11: "Ye have heard of the Patience of Job and have seen the end of the Lord". However incomprehensible Job's suffering may seem, in the end it will not have been in vain.

Lo let that night be solitary
& let no joyful voice come therein

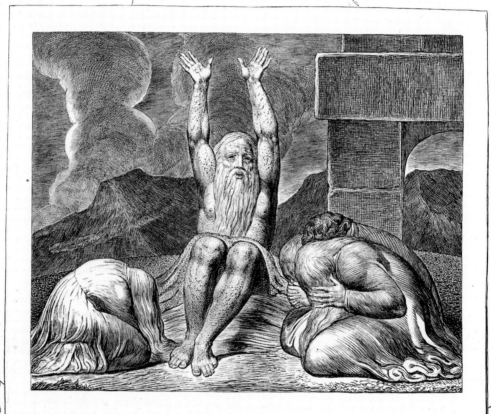

Let the Day perish wherein I was Born

And they sat down with him upon the ground seven days & seven
nights & none spake a word unto him for they saw that his grief
was very great

London Published as the Act directs March 8: 1825 by Will Blake N.º 3 Fountain Court Strand

Proof

PLATE 8

Let the Day perish wherein I was Born

After seven days and seven nights of silent grief, in a great outburst of despair Job begins at last to curse his fate: "for the thing which I greatly feared is come upon me . . ." His whole effort had been directed towards security, towards preserving what he had; yet all in vain. He has lost everything. From his rational, materialistic point of view, this has taken away all the value that his life ever had. He longs only for the release of death.

This attitude is typical of what Blake calls the state of *contraction*. Job's knees here, and again in Plate 12, introduce a motif * which he often uses as a symbol of this state, in which man, and all that he perceives, is seen unimaginatively as no more than a puny and meaningless object of the senses, bereft of all the spiritual greatness and splendour which is perceived by one in the opposite state of *expansion* typically expressed in Job's attitude in Plate 18. Job's present despair reflects his blindness to the healing spiritual force that is within him and which, when he is awakened to it, will have the power to raise him up from his fallen state.

Close behind is a heavy "Roman" arch, but the landscape in the background is disturbingly violent and unstable, with jagged, black, apparently displaced, mountains and towering clouds. In the margin raindrops like tears fall from the thick clouds onto the sinister vegetation below, where briars, poisonous berries and toadstools, sharp rushes and the deadly thornapple recall yet again the curse with which Adam was expelled from Paradise.

*derived from Michelangelo - see Jean Hagstrum
'William Blake Poet and Painter' Pl.17.

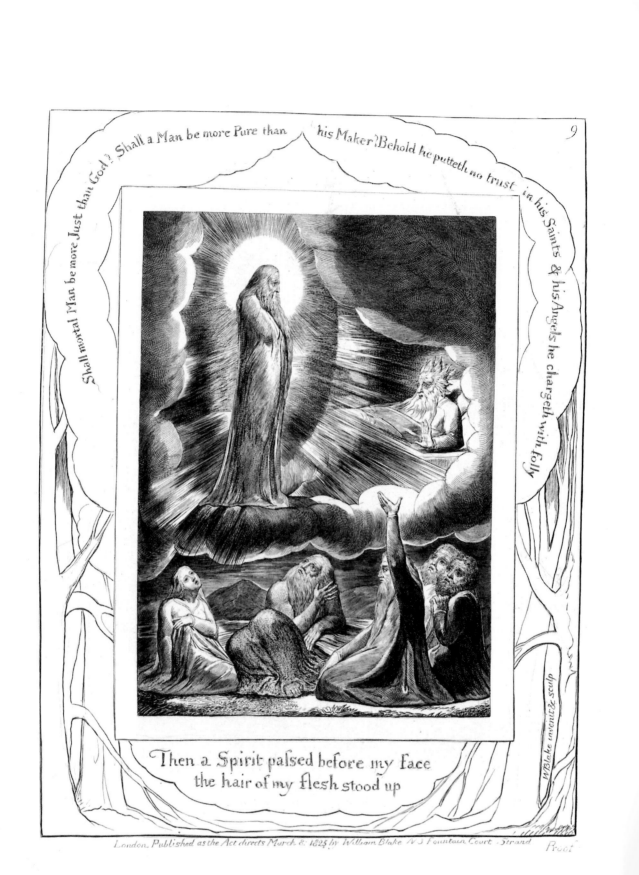

Shall mortal Man be more Just than God? Shall a Man be more Pure than his Maker? Behold he putteth no trust in his Saints & his Angels he chargeth with folly

WBlake inv. & sculp

Then a Spirit passed before my Face
the hair of my flesh stood up

London, Published as the Act directs March 8: 1825 by William Blake N 3 Fountain Court Strand Proof

PLATE 9

*Then a Spirit passed before my face
the hair of my flesh stood up*

A very large part of the Book of Job, from Chapter 4 to Chapter 31, is taken up with a long and fruitless argument between Job and his three friends. The basis of this discussion is theological, concerning the nature and the justness of God. The three friends maintain that since God is just, Job must have sinned or he would not have been punished; but Job always protests his innocence. This illustrates the futility of an argument based on received doctrine into which no new insight is introduced: it goes round and round in interminable circles, finding no answer. Job cannot see any reason why he should have been punished.

Blake only devotes three plates to all this. He is not much concerned with the substance of the argument, which fails to reveal the true source of Job's troubles. This is within his own mind, and it is there that they can be resolved.

Plate 9 illustrates the first speech of Eliphaz, who describes his terrifying dream, which is depicted above the cloud layer. His vision is dim: "I could not distinguish the form thereof". His image of God, the authority behind the moral law, is both menacing and inscrutable, an all-powerful father-figure with

no hint of mercy or pity to temper justice: how can a mere mortal dare to question the judgments of such a God? No man can be perfect in his eyes. But he does say "happy is the man whom God correcteth; therefore despise not thou the chastening of the Almighty" and suggests that it is all for Job's good and that his fortunes will be restored in the end. Job takes little comfort from this. Yet there is truth in it, even if Blake chooses here to emphasise the error in Eliphaz' views.

A massive Cloud of Error hangs over the head of the terrified Eliphaz in his bed. He sees the true numinous value of the spirit, but attaches it to an inadequate image of God, thus creating a deluding "mystery". Indeed any attempt to describe or define the indescribable ultimate reality can only result in such a delusion if it is believed in. Therefore in the margin the proliferating Tree of Mystery grows into the Forest of Error, obscuring the truth and obstructing the way that leads to it. Like the labyrinth or the wilderness, the trackless forest is a symbol of the difficult mental terrain that has to be penetrated in the course of the search for the goal - the Promised Land, or the Holy Grail, of true liberating perception and understanding.

But he knoweth the way that I take
when he hath tried me I shall come forth like gold

Have pity upon me! Have pity upon me! O ye my friends
for the hand of God hath touched me

Though he slay me yet will I trust in him

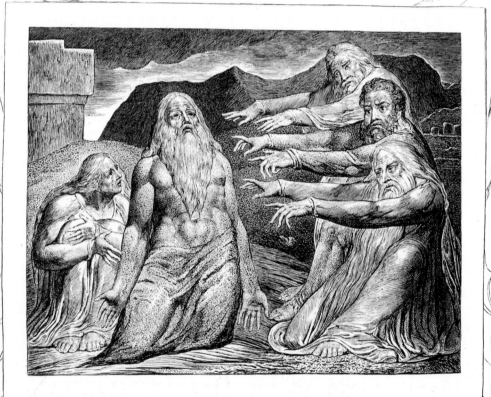

The Just Upright Man is laughed to scorn

Man that is born of a Woman is of few days & full of trouble
he cometh up like a flower & is cut down he fleeth also as a shadow
& continueth not And dost thou open thine eyes upon such a one
& bringest me into judgment with thee

W Blake invent & sculp

London Published as the Act directs March 8: 1825. by William Blake N 3 Fountain Court Strand

Proof

PLATE 10

The Just Upright Man is laughed to scorn

Here is another of Blake's recurring images, that of the three pointing accusers.

The three friends continue to argue that since God is just, Job must have sinned; yet none can say what his sin may have been. This does not apparently deter them from accusing him. He knows he has not disobeyed the moral law and cannot understand why he has been so unfairly treated. He is convinced that when he is given the chance to vindicate himself as in a court of law, he will be able to prove himself innocent and his punishment will end.

Yet, for all his protestations of innocence and his trust in God, he is clearly hurt by these accusations and uneasy. Indeed this is really an image of paranoid guilt which makes him see everywhere the pointing fingers of accusation. His wife, his inwardness, looks at him questioningly. She knows what he will not admit to himself - that there is a real cause for this guilt. However well he may succeed outwardly in obeying a rational moral law, in doing so he is false to himself. This obedience to an external, quasi-parental, authority is a way of clinging to a state of childish dependence which is unworthy of a mature adult. It is a repudiation of his own personal authority, an abdication of his individual responsibility, and makes itself felt as a failure in integrity and a sense of inferiority. Job attributes to others the scorn which he feels inwardly for himself. Moreover,

no man can ignore his natural feelings and impulses and force himself into an externally imposed mould of that kind without producing an inner conflict. What is suppressed will give rise to forbidden desires of a debased and compulsive nature, which are hard to control. These are a more obvious source of guilt.

In the margins heavy chains, which will reappear in the next plate as symbols of enslavement by compulsive sexual desire, threaten to drag down two figures, one of them bearded, who are desperately clinging to the top corners of the design - an image of nightmarish insecurity. These chains, with the bat's wings lower down, suggest that Satan is active within Job as the Tempter, making him insecure and vulnerable to his outward accusers.

In the lower margin, among the trees of the Forest of Error, two birds of prey clutch their victims. Under Job, a grounded eagle,* the bird of the sun, the soaring spirit, holds a small serpent in it talons. This image of eagle and serpent is a traditional one, representing the struggle between the spiritual and the earthy elements; and the source of their conflict lies in the false wisdom represented by the owl, the bird of darkness and death, which is below the Accusers, gripping a helpless mouse. It reflects the falseness of their received morality. A small flower beneath the hands of the accusers, added apparently as an after-thought, is presumably the one referred to in the text below, a symbol of mortality.

* Foster Damon sees this as a cuckoo, Kathleen Raine, as a raven. But surely it is a bird of prey.

My bones are pierced in me in the night season & my sinews take no rest

My skin is black upon me & my bones are burned with heat

The triumphing of the wicked is short, the joy of the hypocrite is but for a moment

Satan himself is transformed into an Angel of Light & his Ministers into Ministers of Righteousness

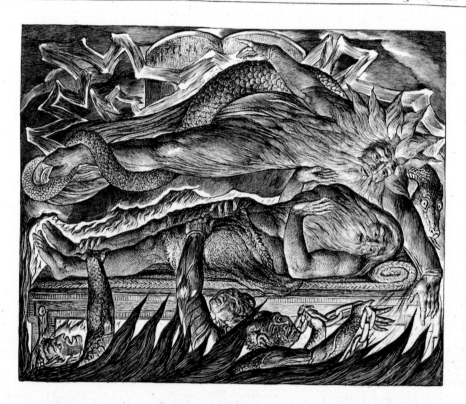

With Dreams upon my bed thou scarest me & affrightest me with Visions

Why do you persecute me as God & are not satisfied with my flesh. Oh that my words were printed in a Book that they were graven with an iron pen & lead in the rock for ever For I know that my Redeemer liveth & that he shall stand in the latter days upon the Earth & after my skin destroy thou This body yet in my flesh shall I see God whom I shall see for Myself and mine eyes shall behold & not Another tho consumed be my wrought Image

Who opposeth & exalteth himself above all that is called God or is Worshipped

W Blake invent & sculp

London . Published as the Act directs March 8. 1825 by Will Blake N 3 Fountain Court Strand

Proof

4.
THE TURNING POINT
PLATE 11

With Dreams upon my bed thou scarest
me & affrightest me with Visions

Here Blake departs from literal illustration to use Job's terrifying dreams, the contents of which are not mentioned in the Book, as the pretext for a powerful image of the conflicting forces at work within his mind, the source of his unexplained guilt.

Job's dream, as imagined by Blake, reflects, in what in these more relaxed and permissive days may seem to us rather an extreme form, the predicament of the man who tries conscientiously to be good according to the received moral law, believing it to be ordained by God.

From the black sea of hell-fire which laps around Job's bed, grinning devils of lust grab at his loins and feet and temptingly hold up to him the fetters of insatiable craving; while from above, the terrifying and merciless image of God bears down on him with flashes of malevolent lightning, pointing with his right hand to the two stone tablets of the unalterable law of good and evil, and with his left, to the chaotic hellfire below, accusing him of sin.

Job's fortunes are apparently at their lowest ebb, yet this plate contains the seed of new and liberating insight. If he could bear to look, he would see that his implacable God of rational justice, the arbiter of right and wrong on whom he feels totally dependent for his security, is none other than Satan, with horns and cloven hoof. And this Satan, also in Job's likeness, is the image of his own spectre, which takes possession of him, as in Plate 3, to condemn others. It threatens him with damnation if he should dare to sin himself. This is the price of identifying with what he believes to be the Law of an external God. It

is the fruit of the knowledge of good and evil according to that Law, the eating of which, or identifying with which, led to the expulsion of Adam and Eve from Paradise by just such a stern and wrathful deity.

However, the hidden motive of this accusing Satan-God is revealed by the large and scaly serpent which is coiled round him, showing him to be possessed by the lust for power. This is Satan in his other rôle as the serpent Tempter, who is traditionally shown coiled round the tree on which that forbidden fruit grew, and who is here also present in another guise in the scaly devils below, arousing sexual lust.

Though the amount of energy caught up in this conflict may vary considerably in different people, the divided will is characteristic of man as a thinking being. It stems from the very nature of the process of thinking.

In order to think, and to communicate through language, we divide up the continuous whole of our experience into things, beings and events, and differentiate between them by describing them in terms of pairs of opposite qualities or attributes, such as, for example, high and low, hot and cold or good and evil, which latter are represented here by the *two* tablets of the rational Law. These opposites are mental concepts, useful for practical purposes; but they exist only in the mind, and are meaningful only in a comparative sense relatively to each other. Yet we often deludedly seek one of such a pair as if it could exist without its opposite. We seek pleasure and avoid pain, we want to be strong and to avoid weakness, and we try to be good and not bad

PLATE 11

according to the values of those on whose approval we feel we depend. These seem to be obvious choices; but we might as well look for an object with a front but no back, a top but no bottom and a right side but no left.

However much we may try, we can never really choose what to be. Though we may believe in the idealised self-image which secures us acceptance and regard it as our real self, what we have to disregard in order to believe in it doesn't just go away. If suppressed, it has ways of asserting itself indirectly by making us act compulsively against our adopted rôle; and that becomes a source of guilt and insecurity, of vulnerability to the Accuser. But if we are to preserve that self-image, our compulsive behaviour must on no account reveal what is suppressed; so

what we pursue is always a compensatory substitute for it. However, indulging the substitute can never satisfy the real need; so, though it may seem to promise release, it actually brings enslavement to insatiable desire, as Blake suggests with the chains held up by the scaly devils of temptation. But the opposite part of the will, that which pursues moral rectitude, is no less deluded. Though Job is apparently caught between two evils, two opposite sides of Satan, these arise from what he sees as two conflicting kinds of good, each of which seems to promise the experience of numinous meaning. One of these is perfect love, divine love, as the reward for being perfectly good; and the other is unalloyed pleasure, to be gained through total self-indulgence. Neither is actually attainable.

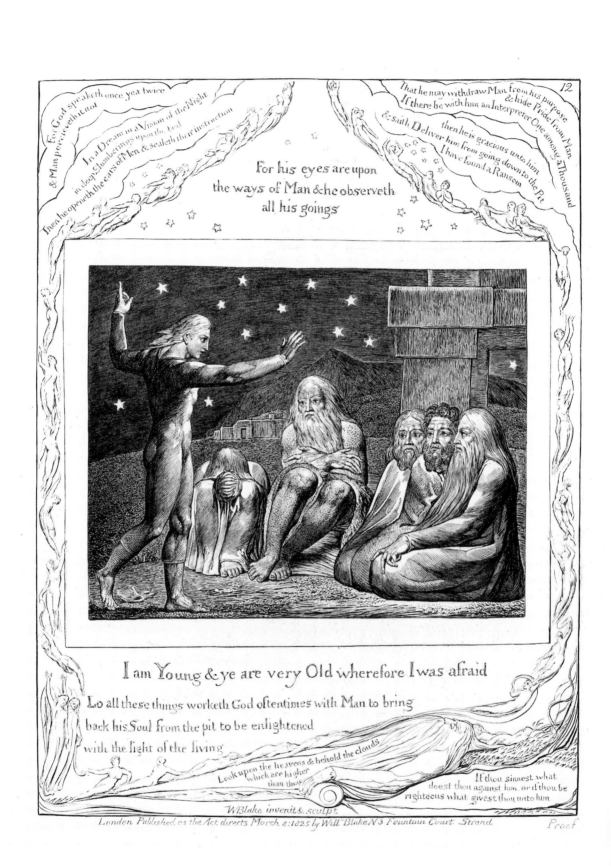

Text within the engraving:

12

For God speaketh once yea twice & Man perceiveth it not

In a Dream in a Vision of the Night in deep Slumberings upon the bed

Then he openeth the ears of Men & sealeth their instruction

For his eyes are upon the ways of Man & he observeth all his goings

That he may withdraw Man from his purpose & hide Pride from Man

If there be with him an Interpreter One among a Thousand

then he is gracious unto him & saith Deliver him from going down to the Pit

I have found a Ransom

I am Young & ye are very Old wherefore I was afraid

Lo all these things worketh God oftentimes with Man to bring back his Soul from the pit to be enlightened with the light of the living

Look upon the heavens & behold the clouds which are higher than thou

If thou sinnest what doest thou against him, or if thou be righteous what givest thou unto him

WBlake invenit & sculpt

London Published as the Act directs March 8:1825 by Will Blake N 3 Fountain Court Strand

Proof

5.
REGENERATION
1. VISION
PLATE 12

*I am Young & ye are very
Old wherefore I was afraid*

Job and his friends have argued in vain: no new understanding has emerged. They are all in the state of spiritual blindness which Blake called Ulro and their arguments are based on received teachings, not on any direct insight. Job is again depicted in the attitude of *contraction*.

But at this point the young Elihu, who has been silent hitherto can restrain himself no longer. Disillusioned with the supposed wisdom of his elders, at last he speaks out. He is not blinkered by their conventional ideas but thinks for himself; and his fresh, direct, way of looking at things provides what is needed to change the unprogressive circle of their argument into the progressive spiral of Regeneration. In this he is reminiscent of the Pure Fool of the Grail legends, who, in his youthful naïveté is able to ask questions which no-one else dare ask and so end the state of stagnation.

It is perhaps debatable whether all of Elihu's words in the Book are worthy of the rôle in which Blake seems to have cast him; but, as depicted, his expression and bearing, his attitude of *Expansion,* and the bristling of his hair, proclaim that he is inspired with prophetic vision. He is a messenger who points the way for Job to see for himself, the Interpreter mentioned in the top margin who can help him to understand. He points to the eternal starry heavens and the vastness of the works of God, and to Job's presumption in questioning God's justice, as if he could really understand God's purposes, as if he could bargain with God for favours - "If thou sinnest, what doest thou against him, or if thou be righteous what givest thou unto him".

Elihu points to the infinite *power* of God and to the need to submit to it trustingly, unquestioningly. God is not only Order and Reason and Moral Judgment, but Will and Energy too. He says: Lo all these things worketh God oftentimes with Man to bring back his soul from the pit to be enlightened with the light of the living".

This is a message of faith.

Faith, as distinct from dogmatic belief, means trust in the inner source of insight and guidance. It means facing the truth with resolute courage - both the objective truth of what *is* and the subjective truth, the values to which we feel intuitively we must be true, the core of our integrity. It also means accepting the necessity of sacrifice and loss as the way to wholeness. But knowledge of the truth is cumulative - once gained it cannot be lost. Experience will only confirm our trust in this inner guidance, leaving no place for the despair to which Job has been driven. The main channel through which its messages come to us is the creative imagination - Blake's Poetic Genius, but they also come in dreams.

Elihu, himself the embodiment of the Poetic Genius, points up to the heavens, the source of eternal and universal values, the realm of archetypes, and tells of the ways in which God speaks to man: "In a Dream in a Vision of the Night Then he openeth the ears of men & sealeth their instruction".

It is night, the season of sleep and dreams, the feminine sphere of the soul which Blake

PLATE 12

calls Beulah, the inward source of vision and inspiration. The Daughters of Beulah, like the Muses, bring these to us out of the darkness of the hidden regions of the mind:

There is from Great Eternity a mild & pleasant rest
Nam'd Beulah, a soft Moony Universe, feminine, lovely,
Pure, mild & Gentle, given in mercy to those who sleep,
Eternally Created by the Lamb of God around,
On all sides, within & without the Universal Man.
The daughters of Beulah follow the sleepers in all their dreams
Creating spaces, lest they fall into Eternal Death.

F.Z 1. 84–90.

In the margins they bring to the sleeping Job dreams which carry new insights, written on scrolls, and form a link between him and the Starry Heavens of eternal archetypal realities. But such messages, like those transmitted by Blake himself, are of no avail unless we recognise their value and work to understand them "For God speaketh once yea twice & Man perceiveth it not." Though they are not directly apparent, eternal truths are to be found in dreams, myths and works of art. With skilful and imaginative interpretation, these can provide a valuable means of circumventing the censorship of the conscious self which, when awake and active, always seeks to protect the illusions with which it is identified.

Job's left hand rests on an unopened scroll as he dreams: the time for interpreting these messages is later, after we have received the images complete without tampering with them.

In the heavens to which Elihu points are twelve bright stars. There are also twelve stars in the triangular space in the upper margin. This repetition of exactly twelve stars on this twelfth plate draws attention to the symbolism of numbers. Like some other significant symbolism in the series, this was introduced only in the later versions of this design.

Blake often uses the stars, with their relentless motion, following the unalterable mechanical laws of the Newtonian universe, as an image of rigid, rational, morality - that is, when they are seen according to the reductive half-truth of scientific objectivity. But, seen with imagination, the fixed stars can also be, as here, symbols of the eternal. Twelve is the number of completeness; and the twelve stars stand for the twelve signs of the Zodiac which form the complete circle. Twelve is also the number of the tribes of Israel and of the Apostles, while the New Jerusalem of the Apocalypse is twelve-fold in all its attributes, a mandala form like that of the oriental royal city, representing unity, wholeness and perfection. This idea is reflected in the reuniting of the twelve members of Job's family in the last plate of the series in the redemption to which Elihu is pointing the way.

Just above the sides of the triangle of figures at the top are two other groups of stars, on the right, the seven stars of the Pleiades, and on the left, the three of Orion's Belt. These constellations, symbolising freedom and bondage, appear more prominently in Plate 14, where their meaning will be considered more fully.

In Blake's system the number three is associated with Beulah, four with Eden. Three is the number of becoming, of the struggle through the Forest of Error in the temporal world, four that of completeness and eternity. Beulah is the realm of dreams, of the moon, the feminine - three is the number of Job's daughters; Eden is the realm of eternal unchanging truth, of the sun, the masculine. The number seven has already been discussed in connection with the seven angels of the title page. It is the number of the days of the Creation, of the notes of the diatonic musical scale and the celestial spheres of the seven moving planets known to the ancient world, associated with change, with the rejection of error, preparing the way for salvation. Possibly Job's seven sons may have some such creative rôle.

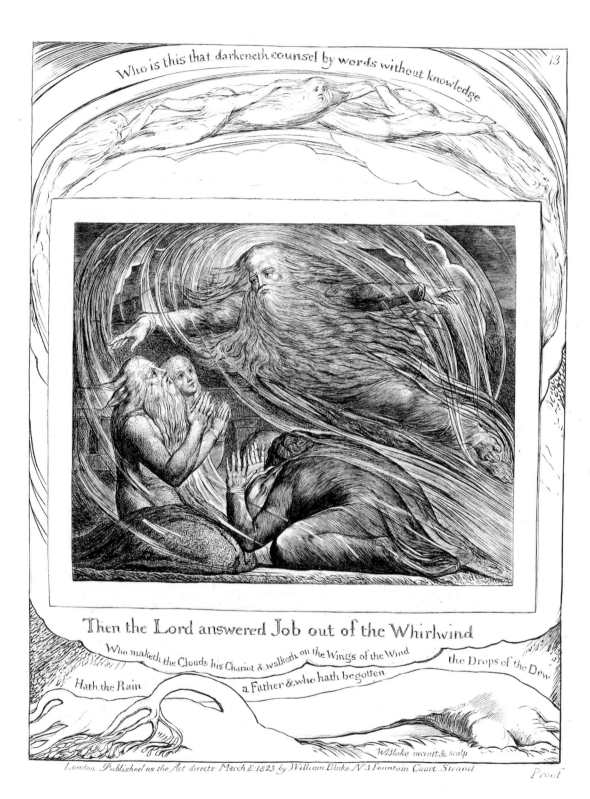

13

Who is this that darkeneth counsel by words without knowledge

Then the Lord answered Job out of the Whirlwind

Who maketh the Clouds his Chariot & walketh on the Wings of the Wind

Hath the Rain a Father & who hath begotten the Drops of the Dew

WBlake invenit & sculp

London Published as the Act directs March 8: 1823 by William Blake N 3 Fountain Court Strand

Proof

PLATE 13

Then the Lord answered Job out of the Whirlwind

Elihu's words have fallen on fertile ground. Now Job's own hair bristles with fearful, but inspired, vision. He takes a fresh look at the realities of life. There is no escaping the fact that natural disasters like whirlwinds strike down the good and the wicked alike. Obeying the Law is no protection against their elemental violence, or for that matter against human violence, let alone disease; and Job has been a victim of all of these. This is the harsh reality - it was childish to cling to the cosy illusion that God rules over us like a father over his children, and to complain that as he had been a good boy it was not fair that he should suffer. The hard, destructive, aspect of God - or of reality - is now apparent to him.

Thus "the Lord answered Job out of the whirlwind", saying "Who is this that darkeneth counsel by words without knowledge? Gird up now thy loins like a man; for I will demand of thee, and answer thou me." God describes at length the marvels of his creation. What does Job understand of all these things? "Shall he that contendeth with the Almighty instruct him? he that reproveth God let him answer it". And later: "Wilt thou also disannul my judgment? Wilt thou condemn me, that thou mayest be righteous?"

Here the awesome image of God is very similar to that in Plate 11. But this time he has human feet and faces the other way, as if to say: "On the contrary, God is not just the principle of fixed law and order, but also that of energy, of change, of creation and destruction." The way he now faces is conventionally that of redemption as opposed to damnation.

God's speech ends with a description of Behemoth and Leviathan, two mighty creatures beside which a man's strength is as nothing. These are God's creations just as much as is Job himself. In the right hand margin of Plate 15 is written: "Of Behemoth he saith He is the chief of the ways of God". The harsh reality which is Behemoth is the reality of power, of brute force. And God created this. The world is not ruled by disembodied, static, rational, justice. Ultimately it is power that counts. This is the "chief of the ways of God", the dynamic aspect of God that Job sees in the whirlwind. Change, conflict, suffering and death are inseparable from life, and there is no appeal against them. It is meaningless to call this unjust; it is how things are. Innocence is no protection.

Job and his wife face this fearful truth with courage - Job looks straight at this image of God (it is an aspect revealed directly through the outer world, so there is no cloud barrier here to mark it off); but his three companions hide their faces in terror. They cling to their complacent illusion of security in the law of a rational father-god. That is all they can understand. Without it they are lost.

Yet this image of God is still in Job's own likeness - these wild forces are also within Job himself; and in Plate 15 Blake will treat the two monsters as unseen inner forces which influence his will.

In the upper margin bearded figures fly in a chain with arms outstretched, echoing the figure of God in the main design. Such cruciform figures of destruction occur frequently in Blake's work, often in the shape of an avenging angel, an irresistible force for the destruction of error. It may be seen as the active aspect of the sacrifice which is symbolised by the Crucifixion. Though their number is not quite clear, these figures could be the seven angels of the title page in a different guise.

47

PLATE 13

On Plate 14 of Blake's relatively early work, 'The Marriage of Heaven and Hell', there is such a figure flying over a corpse which is being consumed in flames.

Below it is written:

The ancient tradition that the world will be consumed in fire at the end of six thousand years is true as I have heard from Hell.

For the cherub with his flaming sword is hereby commanded to leave his guard at the tree of life; and when he does, the whole creation will be consumed and appear infinite and holy, whereas it now appears finite & corrupt.

This will come to pass by an improvement of sensual enjoyment.

But first the notion that man has a body distinct from his soul is to be expunged; this I shall do by printing in the infernal method, by corrosives, which in Hell are salutary and medicinal, melting apparent surfaces away, and displaying the infinite which was hid.

If the doors of perception were cleansed every thing would appear to man as it is, infinite.

For man has closed himself up, till he sees all things thro' narrow chinks of his cavern.

The cavern symbolises matter and the material body, and its chinks are the five senses used merely in a mechanical, unimaginative, way. When Blake speaks of Hell here he is satirising conventional values, turning them upside down.

In the lower margin the wind and the rain have flattened the Forest of Error, which, under the god of rational law, flourished in the margins of Plate 9. The divine wind of the spirit blasts away all that obstructed and obscured it. The rain and the drops of dew, however, suggest mercy and pity, feelings foreign to that god of implacable justice.

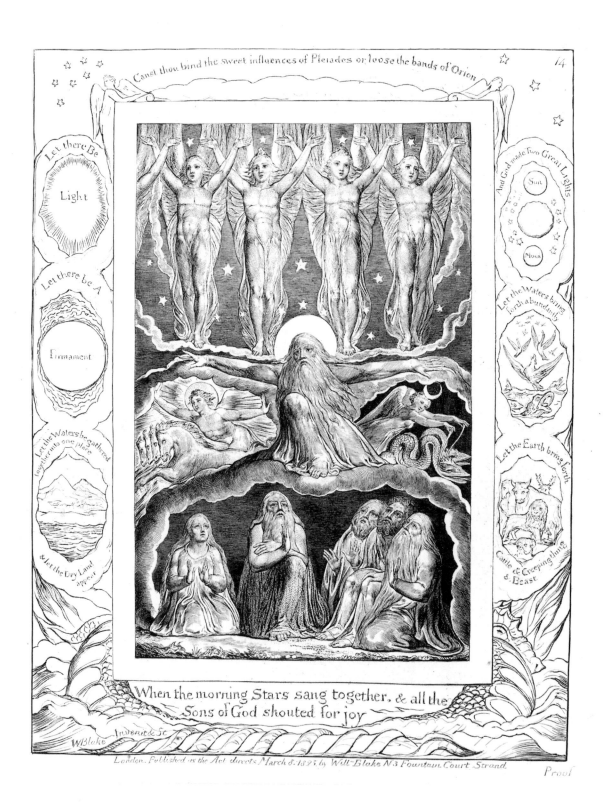

Canst thou bind the sweet influences of Pleiades or loose the bands of Orion

14

Let there Be
Light

Let there be A
Firmament

Let the Waters be gathered together into one place
& let the Dry Land appear

And God made Two Great Lights
Sun
Moon

Let the Waters bring forth abundantly

Let the Earth bring forth
Cattle & Creeping things & Beast

When the morning Stars sang together, & all the
Sons of God shouted for joy

W Blake Invenit & Sc

London. Published as the Act directs March 8. 1825. by Will Blake N.3 Fountain Court Strand.

Proof

PLATE 14

When the morning Stars sang together,
& all the Sons of God shouted for joy

While the previous design represented the power of God in its terrible, destructive, chaotic, aspect, Plate 14 shows its opposite side in a marvellous celebration of Creation, of the divine order, full of wonder and joy. How, Job asks himself, could he ever have presumed to question what is so far beyond his comprehension?

Both the texts and the pictures in the margin of the six days of the Creation indicate that the central, dominating, figure represents God the Creator; yet, as before, this figure of God is in the exact likeness of Job; so it must represent, not the universal divinity, but something personal to Job. Behind it, like a halo, is the sun, a universal image which Blake calls the Divine Vision, just as in Hindu teaching the universal *Brahman* stands behind the individual *atman*. So this God-figure would seem to represent the personal stamp, or "signature", through which the undefined universal spirit enters into a particular life. This concept of the *signature* is to be found in the works of Jacob Boehme, the seventeenth century Christian mystic who was one of Blake's major sources. It defines the individual's law of being. The physical aspect of this might nowadays be expressed in terms of genes or DNA.

A life can then be seen as a process shaped by this individualised parcel of the spirit out of the continual flux of material circumstances. It can be compared with a wave that travels across the sea with an individual form, while the water of which it is composed at any one moment is left behind. Even the body is only a form given to the flow of continually replaced matter which it gathers around itself. When death leaves it without this shaping will, it rapidly disintegrates.

In the lower margin is the ever-changing ocean of chaotic matter, and above it are the flames of untamed energy. These are the two sides of the primal chaos which this creator temporarily reduces to order. Lurking in the ocean is the vast menace of Leviathan, the ever-present danger, which must be unceasingly guarded against, of being swallowed up in the chaos. Not the least of its threats stems from the body's unending need for food. The worm coiled round what Foster Damon describes as a shrouded corpse, associates the flesh with death, both literally and in the Neo-Platonic sense that life in the flesh is a death from the point of view of the unborn.

Above the God-figure is heaven, with its eternal stars and endless row of singing angels, the timeless and boundless source of spiritual truth, of unchanging universal values, the realm of archetypes. Below is the earth, the ever-changing world of particulars, the world of the senses, of time and space, of birth and death. This is the cave-like dwelling place of the conscious self through which Job relates to his wife and friends. It is formed by a thick layer of cloud, which shuts out the light of the sun. The five mortals within it may well represent the five "chinks" of this cavern, the five bodily senses.

The God-figure, the true Centre of Job's individual being and the basis of his integrity, mediates between heaven and earth, relating eternal and universal archetypes to the passing events of the ever-changing world of time and space. This is the proper function of the conscious judgment. This Centre of the individual being, where heaven and earth are joined, is symbolised in the Tree of Life at the centre of the world. Rooted in the earth, its branches reach up to heaven.

51

PLATE 14

Job, the ordinary fallen man below in his conscious identity, is dissociated from this true centre of judgment. To feel secure in the world's approval, he identifies instead with a false image of himself, based on received values, and regards that as the responsible source of his will. He seems to be answerable, as in Plate 11, to an external authority. Yet this external ruling force derives its authority from that of his own judgment, projected onto it as a dependent child projects responsibility onto his parents. This projection of the authority of the Tree of Life onto an external source of fixed values gives rise to the image of the Tree of the Knowledge of Good and Evil.

The God-figure also links another pair of opposites.

Beneath his right hand is a sun-god with wings outspread in flight behind his team of four splendid horses. They charge through the sky with no reins to restrain them, yet in perfect unison. He guides their outward-flowing energy with the Apollonian light of consciousness and reason, thrusting apart the clouds of ignorance and doubt. These outward-going "solar" forces are involved in the execution of the will, making practical decisions with the penetrating power of rational analysis. Reason thrusts apart the "opposites"; yet this unfallen sun-god remains literally in touch with both sides of that mental division. He has not fallen into the error of believing that either can be independent of the other.

Under God's left hand, a moon-goddess with folded wings, holds on short leashes two large and sinister serpents. These represent an unpredictable, Dionysiac, danger, the danger of death. She is the inner darkness, irrational, the embodiment of the "lunar" forces which are involved in the perception of subjective values, the source from which spring not only a man's unruly appetites but also his dreams and the unpredictable magic

of his creative imagination, the source of all meaning in life.

Man's conscious will seems so free and independent, but it is she, Goethe's "eternal feminine", with the exciting allure of the unknown, who activates his feelings and draws him on and can therefore manipulate his will, as Blake indicates, with her "reins".

A very close parallel to this structure may be seen in the Tantric teachings in which solar and lunar channels of energy rise on each side of the central, unifying, channel on which the main *chakras,* or centres of psychic energy, are placed in ascending spiritual order. The same pattern may be found in the Tree of Life of the Cabbalah.

The four compartments around the God-figure correspond to the four constituents of the individual which Blake personifies as the Four Zoas. These are Urizen, the reason, Luvah, the feelings, Tharmas, the body and the senses and Los, spiritual perception. They are roughly equivalent to Jung's four functions of *thinking, feeling, sensation* and *intuition.* Above and below are the perceiving functions of *intuition* and *sensation*; while on God's right and left are the evaluating functions of *thinking* and *feeling.* In the creative act all four are combined in one will.

Creation is, or can be, a continuous process acting through each individual; and as, when the Lord laid the foundations of the earth "the morning Stars sang together, & all the Sons of God shouted for joy", so each creative act of the individual is a source of joy in itself, a small portion of this cosmic joy. Blake's magical picture suggests the numinous quality of that experience, that thrill which gives meaning to life.

Blake repeatedly equates God with the human imagination; and it is action instigated by the creative imagination that brings us this *meaning.* I would say that this has the quality of divinity - not of divinity as a matter of

PLATE 14

externalised religious belief, but as the very substance and driving force of life. That would imply that this experience plays a central, if usually unrecognised, rôle in our ordinary lives, though it comes at very varied levels of intensity.

Creativity is often thought of as a special gift which ordinary people do not possess, something peculiar to artists, scientists, inventors and other exceptional people; but we can all be creative in our own ways according to our talents, using our ingenuity and imagination to solve quite ordinary practical problems, or our skill and judgment in pursuing excellence. We can also be creative in conducting our personal relationships, in making jokes and in playing games; indeed however serious its purpose, there is something playful about any creative activity. And I believe that other creatures also have their own ways of finding this *meaning* through the exercise of their natural capacities.

In most things that we do we aim consciously to produce a particular concrete result. This result may last; but not so the creative satisfaction with which we produced it, the joy in the experience of the numinous which may seem to come as a sort of by-product. That belongs to the moment only and passes with it. So, since we need that creative satisfaction to give meaning to our lives, we must continually seek it anew. We can never be fulfilled once and for all through any one achievement. There is no final goal; but there is a *way*, which in Chinese tradition is called the *Tao*.

The strictly dualistic rational mind demands a distinction between opposites, between subject and object, between the goal which we pursue and the will with which we pursue it; but the reality of the joy of creation is somewhere else, where such distinctions are meaningless, where the way, and the driving force which pursues it, are one. It

exists in the conjunction of what we see as "within"and as "without", self and not-self. We may also think of our own survival and well-being as an end in itself; but I believe it should really be seen as only a means to that higher purpose.

The unqualified, indescribable, reality of what we seek lies outside the reach of rational thought and conscious understanding; so we are easily misled by false promises of it. We have difficulty in distinguishing between the call of the true forward way of creativity and backward-looking yearnings for the womb. Our will is divided into conflicting parts (as in Plate 11).

The present plate marks the culmination of the phase begun with the speech of Elihu. Job now knows the state towards which he must strive, and is ready to begin the actual work which will bring about the necessary change in his perception of the realities of life.

At the upper corners of the margin are again the seven stars of the Pleiades and the three of Orion's Belt. These two conspicuous constellations are mentioned together twice in Job and again in the Book of Amos. In Hebrew mythology, Orion is Kesil, the Fool, said to be a titan who rebelled against God and was bound to the sky by his "belt". As the text between them implies, they represent here the opposite principles of liberation and bondage, corresponding with the free horses and reined serpents on their respective sides, the sides of the redeemed and the damned in all pictures of the Last Judgment. The significance of the titan or giant as the source of the three-fold bondage of Error will become apparent in connection with the equivalent image of Behemoth in the next plate, while the seven principal stars of the Pleiades are no doubt related to the seven planetary spirits of the title page and their function of liberating us from that bondage which is part of the process of human life.

Can any understand the spreadings of the Clouds
the noise of his Tabernacle

Also by watering he wearieth the thick cloud
He scattereth the bright cloud also it is turned about by his counsels

Of Behemoth he saith. He is the chief of the ways of God
Of Leviathan he saith. He is King over all the Children of Pride

Behold now Behemoth which I made with thee

W Blake invenit & sculpt

London. Published as the Act directs March 8. 1825 by Will Blake N3 Fountain Court Strand.

Proof

2. TRANSFORMATION

Plates 12, 13, and 14 have shown a new vision of the spiritual reality bursting into the conscious mind, demanding a complete change of orientation.

But this vision is only the beginning of a long and difficult journey. In Plates 15, 16 and 17, in the light of his new understanding, Job now examines the structure of his own adaptation to life and becomes aware of the illusions and evasions on which it is founded. Only now is he able to look at his life from a standpoint outside his old assumptions and to begin to face what he has not dared to face before, to see how the props to which he has been clinging for security are themselves the source of his suffering and inner conflict. It requires real courage to let go of these props and to sacrifice what seems to be the foundation of his being, his ability to justify himself.

Altogether this is no small undertaking. These three plates are very far-reaching in their implications, and contain statements of such importance, expressed with such simplicity, that it is surprising that, as far as I know, their psychological significance has remained apparently unnoticed for a century and a half in spite of their having been widely known during much of that time. Perhaps they presented too much of a challenge to the basic assumptions by which people used to live. Those assumptions have largely crumbled away now, leaving us uncertain in our values but conscious of the many social problems which arise from this moral vacuum. We are forced to recognise the need to look under the surface; and it seems to me that these plates throw much valuable light on the hidden forces that influence human behaviour. Above all, they show how the apparently conflicting urges between which the divided man is torn all arise from one coherent and comprehensible system. They then go on to indicate how this conflict within the individual may be transcended and wholeness regained.

PLATE 15

Behold now Behemoth which I made with thee

In Plate 15 Blake reveals the underlying structure of the inner conflict.

Job, his wife and friends look down apprehensively at the two monsters, Behemoth and Leviathan, to which God draws their attention. These are also described in the Book of Enoch:

And on that day were two monsters parted, a female monster named Leviathan, to dwell in the abysses of the ocean over the fountains of the waters. But the male is named Behemoth, who occupied with his breast a waste wilderness named Duidain on the east of the garden where the elect and righteous dwell . .

Enoch LX 7-9

In connection with Plate 13, these creatures were taken as symbolic examples of the reality in Nature of brute force as opposed to law; but here Blake shows them enclosed in an underground sphere, apparently treating them, not as external realities, but as psychological forces active, but hitherto unrecognised, within Job's mind.

This sphere, below the ground level of the conscious identity, is divided sharply into two halves. The upper half, occupied by Behemoth, is the dry land, the field of order, reason and conscious control. The lower half is the sea, the chaotic field of unconditioned impulse, of feelings and desires which cannot be consciously planned; and here lurks the female

PLATE 15

monster, Leviathan. These creatures are depicted according to their descriptions in the Book of Job, though Blake has added some details of his own which will be considered in due course. Here one may note that according to Foster Damon, the bulrushes indicate that the sphere is "Egypt", the land of bondage, or repression.

Leviathan's agonised contortions express a desperate craving, to which Behemoth seems stolidly indifferent, cut off from it as he is by the sharp dividing line between land and sea, between conscious control and raw impulse. Leviathan evidently longs for a more cooperative partner to complete a circle of reciprocal giving and receiving.

There are in fact two traditional serpent- or dragon-images each forming such a ring, one consisting of a single serpent (or dragon) biting its own tail, and the other of a pair of serpents each biting the other's tail.

From Eleazar, 'Uraltes chymisches Werk'

The first of these, with a single serpent, known as the *Uroboros* ("tail-eater"), is a symbol of the original undivided Oneness, a self-contained totality. This is a timeless view of existence undivided by any kind of conceptual thought (see commentary on Plate 11). As such it is an "unfallen" view which can be attributed to the unborn child in the womb, where his every need is met automatically and no demands are made on him, so that he has no need to think.

At birth we are expelled from this state of oneness, which in retrospect appears as a lost paradise for which we feel a nostalgic yearning. Blake took the Neo-Platonic view that the "Fall" begins further back, in the moment of conception, in which we are parted from universal and eternal being on entering into individual life, which he called "eternal death". But, whatever its metaphysical starting point, this fall from innocence happens step by step rather than all at once. Even after we are born, at first we cannot have the experience needed to divide up the continuous whole of existence into mental concepts; but in due course we begin to do so, and to develop the idea of self as distinct from not-self; and with that idea comes an awareness of needs which are no longer automatically supplied by the not-self. And, since our parents on whom we depend for all our needs are only human, we may discover that there is a danger of antagonising them if we are too assertive and make unwelcome demands on them. So there is a conflict between our need to get what we want and our need to be loved. Our will is now divided and the division will grow by stages as we become more capable of reasoned action and fall ever further from innocence.

As we grow up we go through many successive steps of separation from mother, each of which may be symbolised as another birth, another gain in independence and freedom; but at each step we also forgo the shelter of a symbolic womb and must accept a greater burden of responsibility and of exposure to the harsh realities of life. Step by step we develop

PLATE 15

the separate individuality and authority that we need if we are to play an active part in the world.

In terms of the serpent symbol, this means that in more and more areas of life the closed circle of the *Uroboros* is opened up. Its separated ends will then take on the opposite polarity of those two opposite sides of the will - the mouth, active and assertive, the will to get what one wants, and the tail, passive and clinging, the need to be loved. Much depends on what opportunities we find in our outward lives to satisfy those needs. Since we are born into an imperfect world, there are bound to be some areas in which they are left unsatisfied, confronted with an apparently uncooperative environment as Leviathan is confronted with Behemoth.

In other words, in childhood we are naturally dependent on our parents: we need their protecting love and seek their guidance; yet at the same time we want to be free and to have our own way. This is the perpetual conflict. But how seriously these needs conflict depends on how secure we feel in the love that we receive. A child who enjoyed perfect, unconditional, love, and who could freely assert his will without fear of losing that love, would have no inner conflict. But in real life, parents are ordinary divided people, and their love is less than perfect. It may be withheld if a child is disobedient, if he shows too much independence of will. To feel that he is acceptable to them he has to block and disown some part of his will.

This alienated energy is represented by the opened-up serpent, Blake's Leviathan. It is not subject to his responsible judgment; so, to avoid being led astray by either of its opposite compulsive urges he has to cling to the fixed moral values that he has been taught, which seem to be backed, as we shall see, by the formidable parental force represented by Behemoth. But that only

perpetuates the conflict. He is apparently trapped in it. And in varying degrees we must all go through this. The "three-fold error" of two opposite compulsive urges with a third, controlling, force pervades our "fallen" lives. The less free and secure we felt in the love that we received as children, the less responsive our parents were able to be to our needs, the more of our energy is likely still to flow into this underground complex, that is to say, the more "neurotic" we are likely to be.

But this is only the negative side of the picture. And it is founded on false assumptions, learnt in childhood, about the world and the place in it of will and authority.

At least some part of our polarised energy will normally find a satisfactory response from the outer world; and this is the meaning of the second of the two serpent-images in which two serpents with reciprocal needs together form a circle. In alchemical lore, this represents the union of Sun (sulphur) and Moon (mercury), masculine and feminine. The same idea is to be found in the Chinese T'ai Chi symbol:

In this union of complementary opposites, of *yin* and *yang*, there is a reciprocal giving and receiving, a complete circle of will, allowing a free flow of creative energy. In this creative union is to be found the numinous experience which is at once the source, and the ever-renewed goal, of all endeavour. The circle is thus a symbol of compelling power, as in Wagner's 'The Ring of the Nibelungen' and

PLATE 15

Tolkien's 'The Lord of the Rings'. It represents the continuing goal of life, the Way. But this power of the ring is ambivalent: it is also associated with the paradise that we lost in the Fall, the false goal of our backward-looking yearnings.

In either direction we are drawn towards this image of oneness, of a blissful state of unconstrained spontaneity with no sense of a separate self, in which we should be free of all inner conflict and guilt; and, as I have suggested, it is not always easy to distinguish between these two directions, so we are often misled. Instead of going forward resolutely with masculine discipline along the hard road which is the way of fulfilment, we tend all too often to look back with soft and self-deceptive longing towards the "womb" that we have lost, though we can never actually go back to it except in makebelieve or fantasy. It means nevertheless that many of us cling to attitudes of dependence which we should have outgrown, trying to escape from responsibilities which are really inescapably ours. This is a source of unaccountable guilt and of the inner conflict represented by the two monsters.

Behemoth

Dependence, in this context, means involuntarily attributing to other people, whether singly or collectively, something of the guiding authority which a child finds in his parents. In adult life this authority may be attributed to "society" collectively as the power behind conventional morality. A mythical figure which may be regarded as a symbol of this collective power is the giant, a sort of debased, unloving, father-figure, entirely unresponsive to his child's needs; and here Behemoth is its equivalent, appearing to lend overwhelming weight to conventional morality, or public opinion, against which there is no appeal.

Blake sees Job caught, as in Plate 11, between his unconscious dependence on this powerful, apparently external, ruling force of order and the two equally powerful compensatory forces from within himself of sexual lust and of aggressiveness, the lust for power, which seem to draw him willy-nilly into conflict with it. These inner forces are represented by Leviathan, whose writhing violence is in sharp contrast with Behemoth's static bulk, and expresses a desperate frustration, a fierce, gnawing, hunger. *

It is dangerous to defy public opinion. Anyone who depends for his security on belonging in a social group wants that group to be strong and stable; and he is anxious to prove that he is an acceptable member of it, that he shares the opinions with which it is identified. But he feels insecure - he knows very well he is not quite what he pretends to be; so he is only too keen to demonstrate his disapproval of those who do not conform, and yet he is jealous of their freedom, which he denies himself. He may actually believe that there is merit in unleashing his ill will against them, and, unwittingly possessed by the Spectre as in Plates 3 and 11, find in this a tempting outlet for his frustrated lust for power.

Since to some extent most other people share this motive for intolerant behaviour, the social pressure to conform can be real enough. It can give the impression that there is a single collective will behind it; and that is what Behemoth represents. However, this monolithic

* This image may be seen to show the interrelatedness of the elements described by Freud as the *Super-Ego* and the *Id* and also of the active and passive aspects of the latter - aggressiveness (the pursuit of power) and sexual desire (the pursuit of pleasure). They are inseparable parts of a whole, and Blake will help us to understand its structure.

PLATE 15

mass with its single set of moral values only exists in the mind of the individual. The reality is that many separate individuals outwardly support the same prejudices so that they can borrow the collective *power* of the group.

These common prejudices do change, but only slowly, because what counts is not what the individual genuinely thinks, but what he believes most other people in his group think. Hence the stupid, sluggish and thick-skinned appearance of Blake's Behemoth, an image which combines massive, collective, power with the inertia of common prejudice. It appears to have little room for brains, yet its eyes, ear and mouth are surprisingly human - "society", or "they", can apparently see, hear, talk and smell, but not think intelligently! In practice each of us has his own slightly different set of values; yet we generally take it for granted that our particular values are universal, even if some people seem to get away with breaking the rules.

It is true that to be socially acceptable we must keep our behaviour within certain bounds; and indeed there is a real need for this - society could not function without rules of behaviour. To maintain a socially acceptable front, one does not actually have to believe in that front oneself; yet to the extent that we remain dependent on the social order that seems to be imposed by "Behemoth" and are afraid of being rejected, most of us continue to cling to some extent to a semi-idealised self-image, believing that it is what we really are. So we disown and suppress from consciousness impulses which are not compatible with it. This amounts to a refusal to go forward into the next stage of separate independence.

We may often unwittingly cling to an illusion of non-separateness and identity of will in a relationship in which one dominates and the other willingly submits so that there is apparently no conflict. In this we may play either rôle according to whom we are with; but either way round, this involves denying a part of our true will. This still exists under the surface and its frustration gives rise to compensatory fantasies of submission or domination.

Leviathan

Blake's Leviathan embodies both of these opposite compensatory fantasies together. It is a crocodile-like version of the mythical dragon or sea-serpent which it is so often the hero's task to overcome, a symbol of polarised, directional, energy; and its scales indicate the "satanic", alienated, state of that energy. Its mouth represents the will to dominate or swallow up the other, and its curling tail, that to submit or to be swallowed up.

Though in reality these polar opposites cannot exist separately, in our fantasies and projections each of them takes on an independent life of its own, and without its balancing opposite, may be carried to the extreme, assuming a quality of absoluteness. Under the influence of the mouth, we may harbour angry dreams of power, of crushing and destroying those with power over us. But as long as we are not free of the unconscious moral dependence which gives them that power, this hostility towards them is a threat to our own security. So we recoil from it. The tail asserts itself with a longing for total surrender, for passive containment in a safe "womb" of perfect love. But to pursue that would only intensify the frustrated will to power. Beneath the controlled and reasonable surface we are compulsively torn between these opposite poles.

Each of these extreme fantasies is seemingly an end in itself; and in Blake's picture these two parts of Leviathan emerge from the sea almost as if they were separate,

PLATE 15

like the two monsters of Greek legend, Scylla and Charybdis, to which, as we shall see, they are closely related; and each of them has its own way of taking over the conscious will at times, unnoticed.

Leviathan's Mouth

Though the will to dominate can appear quite simply as the lust for power, usually it takes over without our knowing it, usurping the power of judgment. Very often, as we have seen, it allies itself with Behemoth and is disguised and justified as moral condemnation or righteous anger. This is the form in which it possessed Job in Plate 3, at the time of Satan's first descent, exploiting the opportunity for its apparently justifiable, and secretly enjoyable, indulgence against his sinful children. But its true nature is suggested by Leviathan's huge, ravenous mouth with tiger's fangs in crocodile jaws, a craving to grip the other with teeth of hatred, to crush utterly. It finds expression in all kinds of aggressiveness, in bullying and sadism, or in personal and collective hatred, in persecution, mob violence and war, where its indulgence may seem to be justified in fighting a threat to order or to common values. It should not be confused with true manly courage.

This fierce aggressiveness is a compulsive compensation for actual powerlessness. As with most anger, it is really an expression of suffering and frustration. And though such aggressiveness seems typically masculine, and may be projected onto men, Leviathan's mouth is nevertheless an image, like Scylla, of the *vagina dentata*, of the castrating, morally domineering, female, that which bites with moral condemnation or unmans with derision. The single masculine weapon of moral authority, being disowned in the act of submission and multiplied by projection onto many others, gives rise to this collectively feminine image with its many teeth which so readily lends its threat to Behemoth. But it also reflects a woman's "animus".

Leviathan's Tail

The impulse to submit with infantile passivity reflects a longing for the comforting arms of mother, the ideal mother of fantasy, totally indulgent. But this nostalgic longing is for a paradise irretrievably lost. The fantasy can never be realised except in makebelieve which cannot bring real satisfaction. Therefore the coiling tail takes the form of a vortex of insatiable craving, like the whirlpool Charybdis, a female water-monster who sucks down her victims with the force of their own desire. In form it is very like the vortex of the souls of the lustful in Blake's illustration to Canto 5 of Dante's 'Inferno' (see opposite).

In a man, the way in which this force exercises its compulsive power is more devious than the unconscious possession through which the mouth operates. Submissiveness is generally regarded as incompatible with masculinity, so a man will usually suppress it. The will to submit then only emerges indirectly as active sexual desire, consciously compulsive, for a woman onto whom he projects it. The basically phallic form of a dragon's tail is coiled up into a vortex of lust, and this coiling character, which represents a man's disowned impotent passivity, his longing to go back into the womb, is reflected in a woman's clinging sensuality which therefore arouses his desire for her.

The erotic nature of this coiling tail-vortex is much more apparent in Blake's image of the apocalyptic beast (see opposite) which is the equivalent of Leviathan,* in his illustration to

* This beast of Revelation, which comes out of the sea, has seven heads, one of which has been wounded, and ten horns. It is by no accident that Blake's Leviathan has a double crest, one with seven points, one of which is blunted, and the other with ten points. Behemoth, with his two prominent tusks, appears to be similarly related to the second beast of Revelation, which rises from the land and has two horns.

PLATE 15

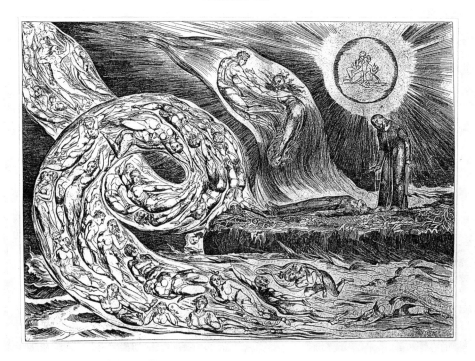

Blake's illustration to Dante's 'Inferno' Canto V
The Whirlwind of the Souls of the Lustful

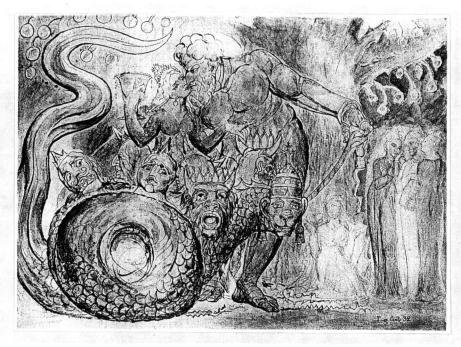

Blake's illustration to Dante's 'Purgatorio' Canto XXXII
The Harlot, the Giant and the Beast with Seven Heads and Ten Horns

PLATE 15

Canto 32 of Dante's 'Purgatorio'. In general, the compulsive kind of sexual interest, or lust, is aroused by people, actions or things, fetishes and so forth, associated with wishes that we hide from ourselves, wishes that we disown (and therefore project) in order to be able to believe in our acceptable self-image. Thus, without recognising the reason for it, we are commonly attracted to people who give expression in some way to an unrecognised, and to us, unacceptable, wish of our own. It is as if some part of us wants in some respect to *be* that person who can acknowledge such a wish, and the force of that wish is displaced into a desire for union with the *person*. This avoids damaging the self-image by making the hidden wish conscious. In this way we hope to satisfy the undifferentiated longing which is all that we know consciously of any of our disowned needs. But this mechanism deceptively substitutes sexual pleasure as the conscious goal, an end in itself. It no more satisfies the original need than swearing cures a bruised thumb. Meanwhile the vortex of desire continues to be fuelled by that unsatisfied need. Just as compulsive aggressiveness should not be mistaken for courage, so such compulsive desire should not be mistaken for love.

What we regard as masculine and what as feminine, and therefore what attracts us sexually as the complementary opposite of our own self-image, is to a considerable extent determined by the social conventions by which we are conditioned, even by ephemeral fashions. Indeed the dividing line between what we identify with and what we disown and project can be drawn in many different ways; and this seems to have an important bearing on the meaning of the many variations and so-called sexual deviations which occur, such as sadism, masochism, narcissism and homosexuality, most, if not all, of which seem to be acquired, not inborn,

characteristics, resulting from outward pressures and problems of relationship in early life. This is not to say that genetic factors may not predispose us to respond in particular ways to those pressures; and that could explain why there may be a strong *statistical,* but not necessarily *causal,* relationship between sexual orientation and genetic make-up, as is being claimed at the time of writing.

The Detached Observer

It is no easy task to free ourselves from the compulsive influence of the monsters, but it is not impossible. It is God, the principle of truth and integrity, the redeeming function within Job, who draws his attention to them. These fearsome unconscious forces by which he is possessed, and which he also projects onto others must be faced and imaginatively understood if he is to heal the division. It is through self-knowledge that he can achieve this. Then he will see the world in a new light, as the source of all opportunity, which will complete the circle and redeem the alienated energy of Leviathan.

If we can come to see objectively how our actual feelings and impulses are affected by these forces and how this affects our own behaviour, we shall have detached ourselves from them to some degree. In this way in our private thoughts we can establish an independent viewpoint as an uninvolved observer, no longer in the grip of the compulsions or tied to the received prejudices by which we may still be ruled in outward life.

It is in the person of this detached observer that we can work to uncover the delusions and self-deceptions on which our false self-image is founded, yet without, for the time being, having to abandon the security of that self-image as the tried and trusted basis of our outward personality. This is inevitably a painful process and requires courage. but the way to enlightenment and wholeness lies

PLATE 15

through sacrifice, not through the building up of self-esteem or the perfection of the "ego". The nature of this inward work can be seen in Plate 16 that follows.

It is interesting to note an eastern equivalent to Blake's image of the two monsters which is to be seen at the centre of the traditional Tibetan Buddhist "Wheel of Life": Here there is no sharp dividing line, and the same three evils are represented by three separate animals biting each other's tails. They are a red cock, representing passionate desire or greed (*raga*), a green snake representing hatred or aversion (*dvesa*) and a black hog representing delusion or spiritual blindness (*moha*). It seems that the sharp division in Blake's design between the force of received morality (the hog-like Behemoth) and the two opposite compensating compulsions (Leviathan) arises from the Judaeo-Christian tradition of a divinely ordained moral code, rigidly separating good from evil. The Buddhist moral code is not backed by any threat of divine disapproval or punishment, but is regarded as both a social necessity and a guide to good *karma*, a help in avoiding pitfalls which would lead to unnecessary suffering and hinder one's progress towards wholeness and enlightenment.

The difference between the two images surely reflects a difference between the typical personality structures of East and West. One may note also that Buddhist and Hindu temples are for individual worship, whereas churches, synagogues and mosques are meeting places designed for the collective ritual affirmation of the divine authority behind the received values set out in the scriptures, strengthening the effective influence of "Behemoth" in the minds of the congregation.

Detail from a wood-block print from Nepal

63

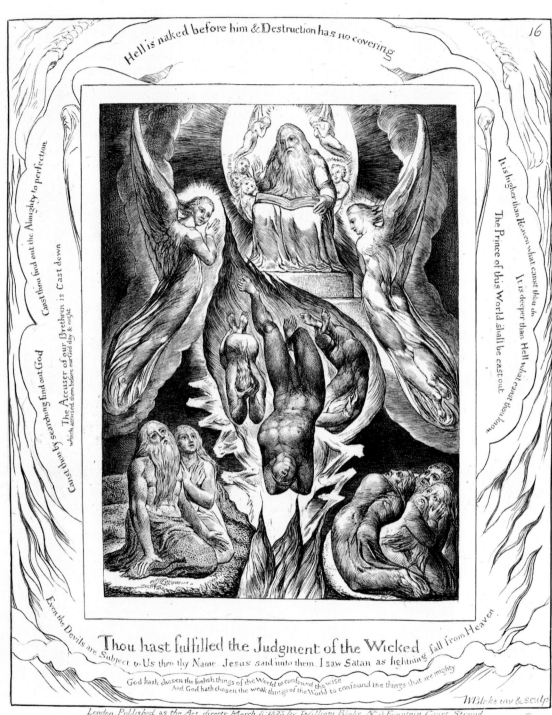

Hell is naked before him & Destruction has no covering

Canst thou find out the Almighty to perfection

Canst thou by searching find out God

The Accuser of our Brethren is Cast down
which accused them before our God day & night

It is higher than Heaven what canst thou do

It is deeper than Hell what canst thou know

The Prince of this World shall be cast out

Even the Devils are Subject to Us thro thy Name. Jesus said unto them, I saw Satan as lightning fall from Heaven

Thou hast fulfilled the Judgment of the Wicked

God hath chosen the foolish things of the World to confound the wise
And God hath chosen the weak things of the World to confound the things that are mighty

W Blake inv & sculp

London, Published as the Act directs March 8: 1825 by William Blake N.º 3 Fountain Court, Strand.

Proof

PLATE 16

Thou hast fulfilled the Judgment of the Wicked

This design can hardly be said to illustrate anything described in the Book of Job, though the words of the title do come from a speech of Elihu as rather dubiously translated in the Authorised Version.

Blake has used these words (entirely out of context) as a pretext for what is a greatly simplified version of his image of the Last Judgment, of which four known examples survive. In his description of another one, which is now lost, he writes: "Whenever any Individual Rejects Error & Embraces Truth, a Last Judgment passes upon that Individual." In other words, interpreting the symbolism of the Apocalypse on the level of the individual, what he means by "a (not *the*) Last Judgment" is a moment of illumination, one of many, in which a new aspect of the truth comes home to us, bringing about some permanent change in our view of life.

A peculiarity of all of Blake's representations of the subject (see illustration p. 68), including the present one, is that the figures, however many or few, are so arranged as to form the shape of a flower or chalice, containing the God-figure at its centre. This is the feminine symbol of love and compassion, of the created world (or woman) as the source, like Dante's Beatrice, of the experience of the divine truth. It is represented by the Holy Grail, the lotus and other flower symbols.

In the present, very much simplified, design, this cup-shaped symbol of love is formed by two compassionate angels (these appear to have their origin in the two cherubim, one on each side of the Mercy Seat over the Ark of the Covenant, from which the Lord would commune with Moses *. In it is contained the Truth which is to be Embraced, and from it the three-fold Error is being

*see VLJ p.85 and Exodus 25.17-22

Rejected. This makes a breach in the barrier of cloud which till now has obscured the Truth and separated Job's conscious self from his true centre of being. The Truth which is thereby revealed is not the *spectre*-god of implacable justice in which Job had formerly believed, but a god of love and compassion. It is still in his own image, a projection of his own *humanity*, his own spiritual centre.

Blake wrote:

Each Man is in his Spectre's power
Until the arrival of that hour,
When his Humanity awake
And cast his Spectre into the Lake. J. Pl.37

"Satan as lightning falls from Heaven", a large neuter figure, accompanied in his fall by two smaller figures behind his back, one male and the other female. Their faces, the faces of Job and his wife, were seen on each side of Satan in Plate 2. In what is suggestive of a birth in reverse, they are to be destroyed as only Error, or illusion, can be destroyed. All three are plunging into the fiery abyss to be consumed in flames as if they had never been.

The large figure with its splendid physique (based on a drawing by Michelangelo) represents the virtuous, idealised, self-image, conforming entirely with the values imposed by "Behemoth". Like all Blake's images of Satan, it has no genitals, no will of its own, its only purpose being to please the world. The wilful sexual opposites on which it turns its back embody the two opposite drives associated with Leviathan. It pretends these do not exist; but they are really inseparable from it, the inescapable result of the repressions by which it is sustained.

Once we have seen that what we regard as our virtues cannot be maintained without giving rise to compensating compulsions which we may regard as vices, how can we pride

PLATE 16

ourselves on those virtues? To rid ourselves of a "vice", it is a "virtue" that has to be sacrificed. To sustain such an artificial "virtue" we have to disown a real need. The "vice" is only a symptom of its repression; so, to become free of the vice, we must restore to consciousness the need which we have disowned.

This is not easy. In our divided state we protect ourselves from direct awareness of anything within us that could jeopardise the false security to which we cling, and at the same time our view of the outer world is distorted by projections of these things that we hide from ourselves; so, as Blake has already indicated in Plate 12, to expose our error and to uncover the healing truth, both inward and outward, we must make skilful use of the more indirect hints provided by the creative imagination and by our dreams, bringing to light and reconsidering the unconscious assumptions which are behind our repressions.

In the person of the independent observer, we are free to question all those received values and duties which we have taken for granted. We may see that beyond all pretences and self-deceptions there is an irreducible reality: *I am what I am; and who shall say that I should not be true to the essence of my own being?* In point of fact, even if I should choose to accept external moral guidance and place my conscience in other hands, this could only be by my own decision. Such a decision would be natural and proper in a child, but to live with integrity as an adult, I must listen to my own inner conscience and take responsibility for my own judgment. To be free of inner conflict I must have the courage to let go of sheltered dependence and to be faithful to my own truth, not to any received idea of duty.

Job had failed to accept this responsibility. His moral surrender had been his primary error, the real origin of his afflictions. It meant that he had continued to follow in adult life a pattern of moral dependence which was essentially childish. This surrender is not just a matter of accepting the framework of laws and conventions which is the necessary basis for a stable society, nor one of giving in to the outward power behind public opinion while consciously retaining an independent view. It goes a step further. One gains a sense of security as an acceptable person by identifying with the received values and adopting them as one's own. This is the temptation to *eat* of the fruit of the Tree of the Knowledge of Good and Evil, making it part of oneself, which, for each of us, leads to the "Fall" into a state of inner division. Whether consciously or unconsciously, those received values are in effect accorded divine authority. They are not to be questioned. All real adult responsibility for moral judgment is thus disclaimed.

In facing the hidden needs which conflict with those values we shall seem to be confronted with shameful secrets, and a painful sacrifice of pride and security; yet with each such sacrifice we gain a new freedom, relieving ourselves of the burden of having in some respect to be a particular kind of person. That part of the false ideal "falls from heaven", deprived of its sanctity, and with it go its compensating vices. In terms of Plate 11, the tyrannical Satan-God with his received rational morality loses some part of his divine authority, and this reduces the inner tensions and contributes toward the eventual defeat of Behemoth.

Each such Rejection of Error brings more clearly into view the Truth, the source of true guidance. Blake's image of this is of a compassionate God surrounded by infants. Elsewhere in the above description of his 'Vision of the Last Judgment' he says that the infants emanating from the figure of God

PLATE 16

represent "the Eternal Births of Intellect from the Divine Humanity", or in other words, the ever-new imaginative perceptions of truth from within - he uses the word "intellect" in quite a different sense from the modern one. These must form the basis of sound judgment.

The Last Judgment Petworth House

68

He bringeth down to the Grave & bringeth up

We know that when he shall appear we shall be like him for we shall see him as He Is

When I behold the Heavens the work of thy hands the Moon & Stars which thou hast ordained . then I say . What is Man that thou art mindful of him? & the Son of Man that thou visitest him

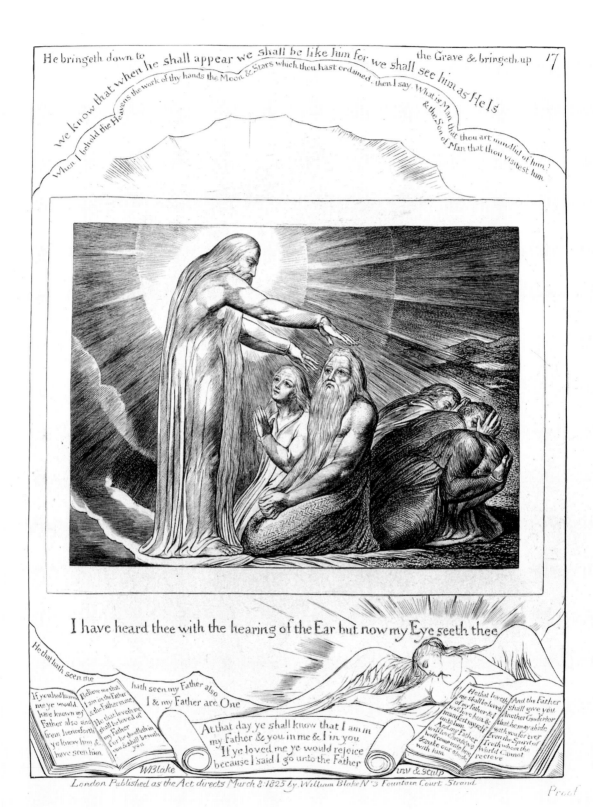

I have heard thee with the hearing of the Ear but now my Eye seeth thee

He that hath seen me hath seen my Father also

If you had known me ye would have known my Father also and from henceforth ye know him & have seen him

Believe me that I am in the Father & the Father in me He that loveth me shall be loved of my Father for he dwelleth in you & shall be with you

I & my Father are One

At that day ye shall know that I am in my Father & you in me & I in you If ye loved me ye would rejoice because I said I go unto the Father

He that loveth me shall be loved of my Father & I will love him & manifest myself unto him And my Father will love him & we will come & make our abode with him

And the Father shall give you Another Comforter that he may abide with you for ever Even the Spirit of Truth whom the World cannot receive

WBlake inv & sculp

London Published as the Act directs March 8 1825 by William Blake N 3 Fountain Court Strand

Proof

PLATE 17

*I have heard thee with the hearing of
the Ear but now my Eye seeth thee*

Job is still seen in his fallen state, but for the last time in the series. He has reached the final stage of his painful inner journey of Experience and is about to be re-born into a new phase of life. Having passed through many "Last Judgments", he has rejected much of his Error and embraced more and more of the Truth. He now finds himself face to face with the embodiment of this Truth, the image of God which is in his own likeness, the image of his true Self.

This is an inward vision - it is not Job in his conscious masculine identity, but his wife, his inward receptiveness, who is looking directly at the God-figure. But he is still separate from it, still identified with that illusory self through which, unlike his benighted friends, he seems to secure its blessing and fatherly support.

Those friends cower in his shadow in fear of the light of the Truth, the "Spirit of Truth which the World cannot receive" as is written in the book below. They face away from it and cover their eyes (though curiosity does drive Bildad to take a cautious peep). That shadow is cast by Job's complacent self-righteousness. He turns his back on his friends - he does not value them.

On the Cloud of Error in the upper margin is written "What is Man that thou art mindful of him?" But this negative and reductive attitude receives a resounding rebuttal. In the lower margin a female angel of compassion is writing words from the Gospel of St. John spoken by Jesus at the Last Supper on the eve of his crucifixion. In effect they repeatedly state that "I am in the Father & the Father in me" and "I am in my Father & you in me & I in you". Altogether divinity is within Man, and, for Blake, Jesus is above all the symbol of the Divine Humanity; and this value is in

every man and woman, in Job's benighted friends no less than in Job himself. Jesus spoke these words on the eve of his crucifixion; and this is the eve of Job's sacrifice, his own symbolic crucifixion, the condition of his re-birth, or resurrection; though if Blake really intended to make a point of this, he chose a rather obscure way of doing so! Indeed though he will depict the actual sacrifice, he does curiously little to indicate that this is a sacrifice of "self" which requires considerable courage. To let go of the self-ideal which has served as one's guard against being carried away by the forces of Leviathan is a daunting challenge. This is much more graphically illustrated by the story of Jonah.

Jonah was fleeing from the Lord, unwilling to do the Lord's work, and the ship in which he was a passenger became storm-bound and could make no progress. He acknowledged that his disobedience was the cause of the storm, which would only end if he was cast overboard. He had himself thrown into the raging sea, whereupon it immediately became calm. He was swallowed by a great fish which the Lord had prepared, and he prayed to the Lord from within its belly and the Lord made the fish deliver him up onto the shore, after which he did the Lord's bidding.

Like Jonah, Job is faced with huge demands on his courage. He can make no further progress without a similar sacrifice of self, a plunge into the chaotic sea of his uncontrolled energies, where lies the very real threat of Leviathan.

He seems to be caught in a vicious circle: his acceptable self-identity, like Jonah's ship, is his only safeguard against those dangerous impulses, and yet it is his clinging to that refuge which itself puts those forces outside his control and makes them so dangerous.

PLATE 17

He can only resolve the impasse by abandoning that artificial self-identity, as Jonah abandoned the security of the ship, and recognising his real will, whatever it may be. This means facing and *accepting* what he has been hiding from himself, the source of his greatest hidden shame. Once he has done that he will be free to be truly himself. Then there will be nothing to compensate for, so the blind compulsions will cease. He can ride the chaos of life, guiding himself with responsible awareness, separate and independent, and will not be engulfed. With the end of compulsive domination or submission he will see other people as quite independent of him. Instead of the three-fold error by which he has been torn, there will now be only a single way forward towards the divine reality which is to be found in every individual, no longer hidden by projections of unrecognised parts of himself.

The angel writing in the lower margin seems to represent the spirit of compassion as an aspect of God, whose radiance she shares. For Blake, God is the "Great Humanity Divine", that in every human being which, when his vision is freed of obstructions, is capable of recognising its own unlimited value in every other human being. This recognition, that in our innermost being, in our capacity for suffering and joy, we are one, is the absolute reality of compassionate love. As a basis for natural, uncontrived, morality this transcends any received moral law.

There is another aspect of the Sacrifice to which Blake also seems to make a rather indirect allusion.

The scene recalls that of Exodus 33. 9-11, where the cloudy pillar descended to the door of the Tabernacle where Moses was, "and the Lord spake unto Moses face to face as a man speaketh unto his friend." Moses saw God face to face, but the people saw only the cloud (which here rises behind the image of God) -

that is to say, they could not grasp the real meaning of Moses' vision.

Moses' vision, or at any rate Job's vision here, was of the inward sort which can only be perceived by each of us for himself, and that only when he is ready for it. But the people needed something to believe in immediately as a source of moral guidance, a fence against chaos; and as long as we are inwardly divided, we cannot escape this need to believe we know right from wrong, and to feel in our hearts that this knowledge stems from a hallowed source and is not to be questioned. The people of Israel were given the Law which was said to have been received from God. No doubt it was as close an approximation to Moses' vision as they could be expected to understand.

Whatever is to bear the divine authority must be protected as a mystery. A space must be preserved within which reason is suspended and into which the numinous image can be projected. Belief entails a resolve to treat that space as sacrosanct, to close the mind to all questioning or probing within it. So, in symbolic ritual, the cloud of mystery, seen by the people and believed by them to conceal the Lord, was given permanent form as the veil hung before the Ark of the Covenant in which the tablets of the God-given Law were kept in the Tabernacle, and later in the Temple. The veil was a material token of belief, ritually setting apart a place, corresponding to a place in the mind of the believer, for the mystery of the divine. Only the priests, the initiated, were allowed into this holy of holies. Supposedly they would not depend on literal belief, but would understand the esoteric meaning of the dogma.

But it is not only conscious believers whose vision is obscured by a veil. All of us who have a self-image, or "ego", project, however unwittingly, the all-powerful principle of divinity onto a parental image outside ourselves to

PLATE 17

which we believe we must make ourselves acceptable. This seems to have a male aspect, the father-authority, and a female aspect, that which it decrees shall be held sacred. It is the latter which is protected by the veil of virginity. This may include not only the Law, the written word of God (or its equivalent), which may seem to have a protective, maternal, function as a source of security, but also the ideal which it enshrines; and it may be represented by the pure, untouchable, virgin goddess, the Queen of Heaven, an aspect of Mother, perhaps as divine wisdom, who is sanctified and protected by the veil.

So another aspect of the liberating sacrifice is the penetration of this veil so as to demystify whatever has been protected by it in sanctified virginity and to reclaim our own sovereign authority and active responsibility.

The rending of the veil in the Temple was one of the portentous happenings said to have accompanied the Crucifixion. The death of the sacred ideal which has formed the basis of received moral values thus coincides with the penetration of the mystery on which its sacredness has rested.

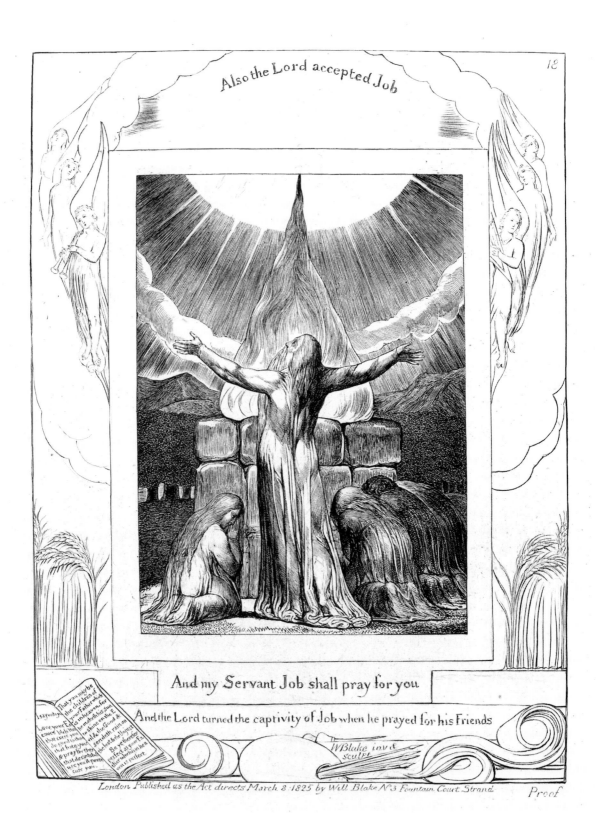

Also the Lord accepted Job

And my Servant Job shall pray for you

And the Lord turned the captivity of Job when he prayed for his Friends

I say unto you That you may be the children of your Father which is in heaven for he maketh his sun to shine on the Evil & the Good & sendeth his rain on the Just & the Unjust Be ye therefore perfect even as your Father which is in heaven is perfect Bless them that curse you do good to them that hate you & pray for them that despitefully use you & persecute you

WBlake inv & sculp{t}

London Published as the Act directs March 8 1825 by Will Blake N 3 Fountain Court Strand

Proof

6.

RESTORATION

PLATE 18

And my Servant Job shall pray for you

Job offers up his sacrifice.

With what seems like a great burst of sound, like a radiantly affirmative chord of C major, the great Sun shines forth. This is the climax. A moment in Haydn's 'The Creation' comes to mind: "And there was light". An orchestra of angels accompanies, but only as a marginal suggestion on a lower plane - nothing so fanciful can be allowed to trivialise the sublime grandeur of the main image.

Job stands up now, healed, robed and dignified, indistinguishable from his former image of God. This is his true Self, the "Seer". He no longer has any self-image - that was never more than an illusion - the Seer cannot see himself any more than an eye can see itself. He can only see what is Other, the "Seen". In place of the personal God-figure with which he has now merged is the huge image of the universal Sun, called by Blake the "Divine Vision". Till now this has appeared only behind the personal God, which was, as it were, its representative within himself, now recognised as the centre of his own being and the source of his true judgment.

The Sun is contained in a shape like a chalice, formed partly by Job, as he opens himself to receive its light, and partly by clouds and angels. Once more this brings to mind the Holy Grail, the symbol of the material world as the outward manifestation of the spirit, of the Feminine, the Other, the "Seen", as offering the experience of the numinous. Job's active masculine love goes out to it, his redeeming courage. It wells up from within him as a great phallic flame, the Fire of the Spirit, the joy of creation and the pain of destruction, rising from the altar of the sacrifice in the region of his heart, transforming and releasing all the energy which was locked in Leviathan and penetrating at last the cloudy veil into the centre of the Sun.

In this union of the flame and the cup (or of the Spear and the Grail) is symbolised the union of the opposites, of Self and Other, of Seer and Seen, of male and female, of power and love. In this conjunction is to be found the spiritual truth, the Sun. This is at once the immediate goal, and the driving force, of the life within him - yet it is neither within him nor within the Other, but in the act of creation itself. In this is his whole reality and purpose as a living being, and it cannot exist without the Other. He cannot create out of a vacuum. This Other, the object of his love, in terms of which he must realise his creative will, is the other half of his own being. It is Dante's Beatrice, the divine truth; it is Blake's Jerusalem, at once woman and city, both the individual woman, and the whole world collectively.

Standing joyfully in the attitude of *Expansion* which is also that of crucifixion, or self-sacrifice, Job has let go of all his former defensive self-consciousness, of any idea of a self around which "his" needs revolve. He only sees the Other and follows the demands of necessity as they appear to him, making no personal choice. He sees the common humanity of all his fellow men and women, and yet loves each one in his mysterious "otherness" as a sovereign individual with his own unique vision, which is the channel in him for the value of divinity.

Job no longer turns his back on his misguided friends. No matter if a person's conscious understanding may seem to be clouded with error or with plain stupidity, no matter how wicked his behaviour, in his innermost subjective being, in his capacity,

PLATE 18

however cruelly distorted and obstructed, for love, for action, for joy and suffering, Job is one with him. He knows in him the Great Humanity Divine.

With this love Job prays for his friends; and he can also love his enemies, as is enjoined in the text from St. Matthew which is written in the book in the lower margin: "that you may be the children of your Father which is in heaven, for he maketh the sun to shine on the Evil & the Good & sendeth rain on the Just & the Unjust. Be ye therefor perfect as your Father which is in heaven is perfect." This is the perfection of wholeness, of not separating good from evil, of not loving the sinful, or those who hurt us, any less than the virtuous, or those who are good to us. All is perfectly what it is. People (though not necessarily their actions or their views) can be accepted as they are. Job knows that all hatred is founded in delusion, in projected images, that what is real is the humanity which he shares with all.

But loving our enemies surely does not mean that we must not fight them or hurt them or indeed that we should have no enemies. Any idea that there is a single divine will which should be the will of all, a single orderly plan according to which all beings should live in perfect harmony, is surely disproved by the simplest observation of Nature "red in tooth and claw" unless it be assumed that the creator and author of this plan is totally inept.

Conflict and suffering must be accepted as inherent in life, and in human affairs no less than anywhere else. The creativity of man is a channel through which seminal ideas of change carry forward the evolution of our world; but man cannot create without destroying. The flame of Job's sacrifice combines these inseparable opposites, like Shiva's playful dance of creation and destruction within the fiery circle of the sun. Nor are

things so ordered that one person's proper creative course does not conflict with another's. But if, like Job, we are fully alive to the human reality of others, we cannot close ourselves to the suffering that we may have to cause. We are bound to suffer it in ourselves. And we shall accept with equal understanding the suffering that is inflicted upon us.

We must accept the world as it is, with all its suffering and all its enormous imperfections as well as its laws and social conventions, as the material for our creative "play". Then we can "build Jerusalem in England's green and pleasant land", here and now. It is not the world that has to be changed if we are to find joy and fulfilment in a creative relationship with it, only our own attitude towards it.

In the previous two plates the divine radiance has been gradually expanding into the upper margin. Here the disc of the sun itself continues in the margin, and on it is inscribed: "Also the Lord accepted Job", as if in answer to his prayer for his friends. In finding them he has found himself. And on another level he has also accepted and integrated that in himself on which he had formerly turned his back.

Trees have now returned to the landscape, an orderly grove, not the labyrinthine Forest of Error; and in the side margins ears of growing corn herald the coming of the spiritual harvest. Nature is also redeemed, and this is celebrated in the next plate.

At the very bottom, Blake himself offers up his painting, his engraving and the scrolls of his poetry, as a prayer for his fellow men, his work of mutual fulfilment, his own way of freedom. The art of music he leaves in the hands of the angels above.

The active principle, the passive principle and the mediating judgment, which formed the three-fold structure of the divided state, have now become three facets of a harmonious

PLATE 18

unity. In Plate 14 these were seen in the sun-god, the moon-goddess and the central God-figure. Here they are represented respectively by the flame, the cup and Job himself in his true identity as the Seer, guided by his perception of the Sun, the spiritual source. Of Plates 18, 19 and 20, each is concerned with one of these facets. Plate 18 shows the return to the spiritual centre, Job's true self, as the single source of will and of judgment; Plate 19 deals with its passive, receptive, side and Plate 20 with its active, creative, aspect.

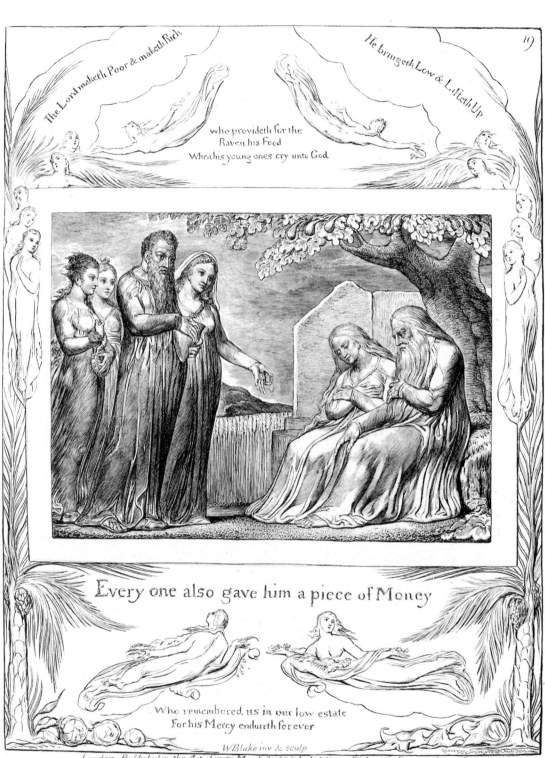

The Lord maketh Poor & maketh Rich

He bringeth Low & Lifteth Up

who provideth for the
Raven his Food
When his young ones cry unto God

Every one also gave him a piece of Money

Who remembered us in our low estate
For his Mercy endureth for ever

W Blake inv & sculp

London. Published as the Act directs March 8: 1825, by William Blake N 3 Fountain Court, Strand

Proof

PLATE 19
Every one also gave him a piece of Money

This plate shows the receptive side of the redeemed Job and the redemption, in him, of love with the restored purity, in his eyes, of Nature and of the feminine. It was on his second descent, shown in Plates 5 and 6, that Satan had brought about in him the corruption of love with hypocrisy and sexual lust.

The scene is that of Plate 4, where Job and his wife were learning of their disastrous losses. Now all is being restored to them, and they gladly accept what the world is gladly giving - the generous love of their fellow men and women and the bounty of Nature. The idea of acceptance is suggested by the concave shape formed by Job, his wife and their fruitful fig tree.

Their friends come, in kindness and affection, with gifts, which they accept with a new, dignified, humility, returning the affection offered to them with unaffected gratitude. This true charity, founded in mutual respect, is in sharp contrast to Job's former hypocritical "demonstration" of charity as a duty on Plate 5, a mere outward show.

Here Blake is celebrating the nobility of individual men and women and the fruitfulness of the earth, presenting the material, the temporal and the particular as an expression of the eternal and universal spirit. Indeed he seems to have lavished extra loving care on this particular engraving, suggesting that the individual is a manifestation of the divinity by depicting, with an exceptional richness of form (more apparent in the original prints than in most reproductions), people of great personal dignity.

The field of standing wheat is a reference to the Spiritual Harvest of the Apocalypse and to the bread of the Eucharist. It signifies the essential purity of the body. There was an allusion to this in Plate 5 in relation to Satan's second descent, where, as an aspect of the corruption of love, bread was given in false charity.

To the fallen man the body appears as an alien thing with a life of its own. "He" knows little about its functioning, which is quite independent of "him". Smelly and disgusting in many ways, "it" has appetites and makes all sorts of exacting demands. Through "it" come pain, disease and death. Because certain desires which arise from it are unrelated to his conscious judgment, they constitute an insidious threat to his self-image. These are the clutching, grinning, devils of Plate 11, obscene and treacherous, a pollution of "his" purity, a desecration of "his" being. "But", wrote Blake in a passage already quoted, "the notion that man has a body distinct from his soul is to be expunged". Mind and body are the "within" and "without" of a single living entity, the body being the expression, in terms of organised matter, of the one living spirit from which consciousness also arises. Properly integrated bodily desires arise from that same source and are therefore perfectly clean and wholesome. This essential purity, the purity symbolised by the Holy Grail, extends to the whole of the material Creation.

In the margins beautiful nymphs are sporting, bearing fruit and flowers. The palm of suffering bears fruit also and the earth brings forth roses and lilies, variants, signifying respectively love and purity, of the flower or Grail symbol. The evil which had formerly been seen in Nature - in the body and in the clinging tentacles and tendrils of the "life force" - was an illusion destroyed with the dragon's tail, cast out with the female part of the triple devil. The unqualified value of the eternal and infinite is to be found in all that is imperfect, vulnerable, erring, earthy and mortal - in the world as we find it, and with which we are one:

For everything that lives is holy, life delights in life
Because the soul of sweet delight can never be defil'd. A. 8. 71-72

How precious are thy thoughts
unto me O God
how great is the sum of them

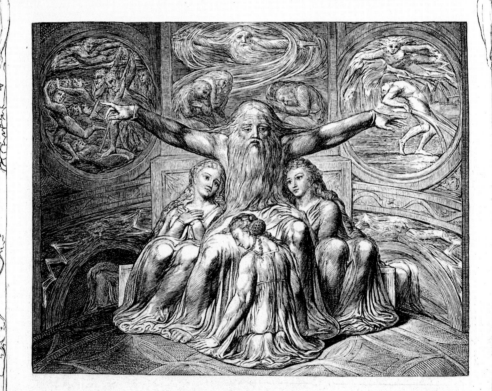

There were not found Women fair as the Daughters of Job

in all the Land & their Father gave them Inheritance

among their Brethren

If I ascend up into Heaven thou art there
If I make my bed in Hell behold Thou
art there

W Blake invent & sc

London Published as the Act directs March 8: 1825 by William Blake N° 3 Fountain Court Strand.

PLATE 20

There were not found Women fair as the Daughters of Job in all the Land
& their Father gave them Inheritance among their Brethren

This plate celebrates man as creator, and the redemption in him of the active force symbolised by the flame or spear.

In the previous plate Job was receiving love and sustenance from the world. His posture was one of humility. Here, in the complementary phase, he is giving and the world is receiving. He sits erect now as the positive phallic principle, filled with inspired vision with which to impregnate the world. He has found the true *Way* and now uses the power of Art to help others to find it. This of course is just what Blake himself is doing. Nothing of the kind is suggested in the Book of Job.

Above is a short quotation from Psalm 139: "How precious are thy thoughts unto me O God" which seems to imply here (though not in its original context) that Job's visionary thoughts are God's thoughts, that the creative man, here the artist, is a channel through which the seminal thoughts of God pass into the world so as to cause it to change and develop and grow. Thus the making of Art is a function of the phallic principle emanating from God-within through the creative imagination (though Art is of course only one of many possible channels for man's creativity). Blake described poetry, painting and music as the "three powers in man of conversing with Paradise which the flood did not sweep away." * The arts are the province of Los, the Zoa of spiritual intuition and of the creative imagination, the only part of the fallen man which retains access to the spiritual reality. The lyre and the lute in the lower margin stand for poetry and music, while painting is represented in the pictures on the walls in the central design.

Job's three daughters, who have now been restored to him and nestle affectionately around him, seem, like the Muses, or Blake's "Daughters of Beulah", to be his inspiration in these three fields (in an earlier version of this design one holds a drawing board, one a small book and the third, a pen and scroll). He is evidently instructing them as he points to the pictures, and they are receptive to his vision.

But man cannot create without destroying. These pictures show this harsher side of the Truth, the "wrath of God", which must also be accepted without reservation. This is Job's message. In the central panel, a miniature version of Plate 13, God with arms outstretched speaks out of the whirlwind, the terrifying God of power, of creation and destruction, of fire and flood. Job himself repeats the attitude of God, as do the angels of destruction who dominate over each of the scenes in the four other panels. It is the attitude of the destruction of Error, of crucifixion or sacrifice.

In the two circular side panels, avenging angels bring down the Fire of God, the indiscriminate lightning, consuming the good and evil alike, the good ploughman on the right, and the evil marauders on the left, who seem to be attacking and killing defenceless, naked, women. In each of the two lower semicircular panels a figure crouches in mourning, with a bearded angel of death above.

These scenes are usually taken to represent Job's own experiences, but apart from the central one, although in a general way they recall the afflictions brought by Satan on his first descent as the devil of power, they do not actually illustrate any of them. But now we see that it is not Satan, but angels, messengers of God himself, who bring death and destruction to the good and to the evil alike. Suffering, death and bereavement are now revealed as part of the working of the divine force, or necessity. They are

* VLJ. pp 80-81

PLATE 20

complementary to the pleasant things of life shown in Plate 19, and equally essential to its meaning.

Job's personal God, the unfathomable I AM THAT I AM, is in the middle, neither good nor evil:

If I ascend up into Heaven thou art there
If I make my bed in Hell behold Thou art there
<div align="right">Psalm 139</div>

Vines climb up the margins and clusters of grapes show that it is the time of the Spiritual Vintage. Like that of the Harvest, this is an image from Revelation often used by Blake in his "Prophetic Books". In Plate 19 the Harvest marked the redemption of Nature and of the body. Here the Vintage, associated with the wine of the Eucharist, the blood of suffering, signals the redemption of the active power of the spirit. In its fallen state this active masculine principle was involved in the abuse of power and authority, which is a debasement of courage. It was responsible for the violence done to Job by Satan on his first descent, shown in Plates 2, 3 and 4.

Accordingly the Vintage here is fore-shadowed in Plate 2 in the vines spiralling up the trees; and whereas in Plate 2 Job proudly holds up the received book of the Law, the sign of his moral submission, here, with the recovery of his own spiritual authority, he points to his own visions, the source of his moral independence and the foundation of true courage.

Redeemed, this spiritual fire from within still has a harsh side as the flame of the sacrifice, as the spear, the power to hurt, to oppose and to destroy. This is the "wrath of God". But at the same time it is the power to create, to act effectively to cause change. It is the organ of creative love, which is true courage, the active love of one who knows the compatibility of conflict and love, as in Plate 19 he knew the spiritual purity of the earthy. The wrath of God is the power and authority, the discipline, which gives meaning and effect to love. This kind of harshness, and the suffering which it causes, instead of being disowned as evil, is now accepted as the will of the true Self. It is the purging fire, the astringency which is the cleanness of love, which without it is mere sentimentality and indulgence.

Great & Marvellous are thy Works Lord God Almighty

Just & True are thy Ways O thou King of Saints

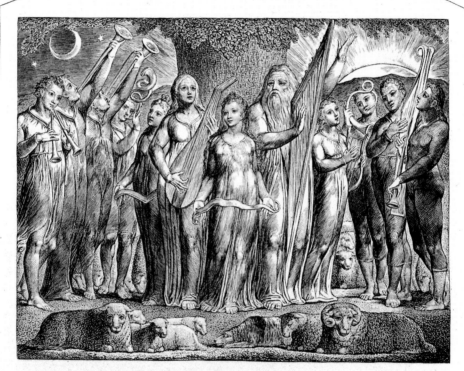

So the Lord blessed the latter end of Job
more than the beginning

After this Job lived
an hundred & forty years
& saw his Sons & his
Sons Sons

In burnt Offerings for Sin
thou hast had no Pleasure

even four Generations
So Job died
being old
& full of days

W Blake inv & sculp

London Published as the Act directs March 8: 1825 by William Blake Fountain Court Strand

Proof

PLATE 21

So the Lord blessed the latter end
of Job more than the beginning

This wonderful picture of the life of the redeemed in the Earthly Paradise has a kind of inner music. It radiates a luminous and peaceful joy deeper than could be conveyed by any outward gestures or facial expressions. This joy is not mere happiness; it is also the willing acceptance of suffering.

The scene is the same as in the first plate of the series. Job is once more with his family under the tree; and his flocks, the signs of his restored prosperity, are all around and now (spiritually) awake and alert. With the new dawn the sun and moon have changed places.

Before, Job and his wife were piously reading standard prayers to an imaginary father-god, far off in heaven, with their children humbly kneeling around them. The sun's light came to them only through the church, and their musical instruments, their creative individuality, hung unused on the Tree - the tree of rational morality whose "letter killeth", as it is written on the altar below. But now they no longer kneel. They all stand up, joyfully, yet seriously, making music together. Each is celebrating the Divine Vision in his own way, improvising the melody which is his life in counterpoint with the lives of the others, a free individual responding creatively with love and imagination to the needs of the world.

Job himself, the leader and head of the family, plays his bardic harp with a flourish. He is now the Seer, the Artist of Life, the mouthpiece of the Poetic Genius, the creative imagination; and around him his wife and daughters are his inspiration in their various fields. His wife is playing the lute, which has previously figured as the symbol for music, one daughter holds the book of faith, another the lyre of poetry, while the one at the centre

of the whole composition holds a small, wavy, scroll, which no doubt denotes Vision, or Inspiration itself.

The Tree, which before was seen as the Tree of the Knowledge of Good and evil, now takes its proper place as the Tree of Life at the centre of the Earthly Paradise. It is the meeting place of heaven and earth, the source of guiding authority and creative power at the centre of being. Its position between the eternal and temporal is suggested by the sun and the moon on each side of it together with the two sentences from Revelation above them in the upper margin, one referring to the Creator and the other to his Creation. The sun is associated with justice, truth and kingship - with eternal principles; while the moon, here on its back, is a cup-like, feminine, Grail image, as it is so often depicted by Blake; and the quotation above it celebrates the marvel of the ever-changing created world.

This world now appears in its true light, "Jerusalem in England's green and pleasant land". Jerusalem is represented here in both aspects, as woman and as "city". The first is to be seen in this central figure, one of Job's daughters. She is a woman of magical beauty, clothed in a shimmering, filmy garment, closely resembling Blake's image of Dante's Beatrice, his exactly equivalent vision of the divine truth in the Earthly Paradise, the object and source of love. Jerusalem as as city, the twelve-fold New Jerusalem of Revelation, is represented by the family group in its twelve-fold complete-ness. This epitomises the enlightened person's view of society as it is, in which all play their parts so as to provide the contrapuntal pattern of tension and

PLATE 21

resolution, of suffering and joy, which gives meaning to each individual life as it does to music.

Time passes and as it carries us with it this meaning must be continually sought again.

The flames on the altar below burn more brightly than ever, but sacrifice now has a different meaning - it is an acceptance of the reality of perpetual change, of the truth that all is transient, that there is no joy in clinging to what one has. It is in the newness of experience, in its being new-born - "the Eternal Births of Intellect from the divine Humanity" - that the joy of creation is to be found. We cannot hold on to such a value, still less appropriate it to ourselves or attach it permanently to any object. But if we seek continuously to renew it, it will determine the shape and rhythm of our lives as they flow through time in a way which is symbolised in the meaningful flow of music. And, as in music, the meaning is not contained in any one instant, but in the whole pattern and also in its parts, its individual themes, sections and movements.